IMAGES
of America
OAK LAWN

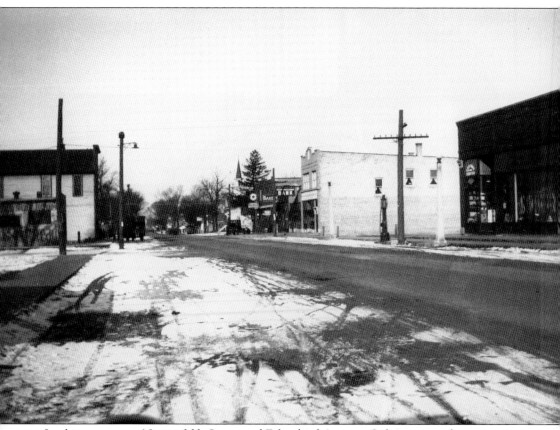

Looking west near Ninety-fifth Street and Fifty-third Avenue, Oak Lawn was home to just over 2,000 residents when this photograph was taken around 1930. On the left is Larsen's Hall, the site of the village's incorporation in 1909, while on the right are, from front to back, Behrend's Hardware, the Oak Lawn Trust & Savings Bank, a bakery, repair garage, and St. Gerald Church. The growing impact of the automobile is evident by the paved road and gas pump located on the corner near Behrend's. (Donated to the library [Oak Lawn Public Library] by Harvey Terpstra.)

ON THE COVER: In October 1949, the first Round-Up celebration was held in Oak Lawn. Although only in its initial year, the Western-themed parade, rides, and games were already drawing large crowds. Round-Up continued as an annual event for another nine years, entertaining thousands of residents and helping to promote the growing community of Oak Lawn. (Courtesy of the Oak Lawn Public Library.)

IMAGES of America
OAK LAWN

Kevin Korst

ARCADIA PUBLISHING

Copyright © 2012 by Kevin Korst
ISBN 978-0-7385-9360-9

Published by Arcadia Publishing
Charleston, South Carolina

Printed in the United States of America

Library of Congress Control Number: 2012932799

For all general information, please contact Arcadia Publishing:
Telephone 843-853-2070
Fax 843-853-0044
E-mail sales@arcadiapublishing.com
For customer service and orders:
Toll-Free 1-888-313-2665

Visit us on the Internet at www.arcadiapublishing.com

To Deanne and Elise and for my family and friends

Contents

Acknowledgments		6
Introduction		7
1.	Black Oaks and Beyond	11
2.	Faith and Worship	23
3.	School Days	35
4.	Building a Community	49
5.	Business and Commerce	63
6.	Government and Politics	77
7.	To Serve and Protect	89
8.	Tragedy and Triumph	101
9.	Celebrations	113
Bibliography		126
Index		127

Acknowledgments

Since its inception in 1961, the Oak Lawn Public Library's Local History Program has been at the forefront of preserving the community's past. Over the last five decades, numerous individuals have guided Local History into new and exciting directions. Without the hard work of staff members, such as Katherine Trimble, Dee Kopf, Carol Adams, Peggy Nevins, Mary Lou Harker, Lillian McAninch, Gordon Welles, William Goodfellow, Maritza Ruiz, and Maureen Gilligan, much of the collection we have today would not exist.

I would also like to acknowledge the Oak Lawn Community Library Foundation, Friends of the Oak Lawn Library, and the Oak Lawn Library Board of Trustees for their continued support of the Local History Program, along with the efforts of many volunteers, especially Pam Koziol, and interns whose time and dedication helped make the program a success. In addition, a thank-you goes out to Oak Lawn residents who have donated or loaned historical photographs, documents, and objects. We are forever grateful for your contributions to preserving Oak Lawn's history.

This book is by no means the complete and definitive history of Oak Lawn. If anyone has additional historical information, photographs, documents, or objects, they are urged to contact the Oak Lawn Public Library's Local History Unit.

Introduction

Among the oldest communities in Worth Township, it is during the early part of the 19th century that the story of Oak Lawn takes shape. In 1835, a number of individuals, some of who were speculators looking to make a quick profit, obtained large sections of land that would one day encompass the village. Much of northeastern Illinois was available for purchase after the last of its Native American inhabitants, including the Potawatomi, were forcibly removed by federal and state governments. With the area open for further white settlement, men and women such as James B. Campbell, Sophia Laughton, and Junius Hatch became some of the first landowners.

In the 1840s and 1850s, settlers made their way into what was then known as Black Oaks. Some of the earliest families to arrive included the Simpsons and Chamberlains, both of who figured prominently into the village's early history. The Chamberlain family, led by Franklin and his wife, Rebecca, left Canada in 1837 and made a home in Blue Island before arriving in Black Oaks during the 1840s. John Simpson, an immigrant from Scotland, purchased land in 1842 for just over 62¢ per acre but did not permanently settle with his family until the 1850s.

As the early settlers of Black Oaks were laying the groundwork for its future development, internal strife over the question of slavery threatened to tear the larger nation apart. In December 1860, Southern states began to succeed from the Union, pushing the United States into the Civil War. For the next four years, the conflict impacted even the most rural of areas, drawing men from Black Oaks and other nearby settlements into military service and claiming the life of Wilbur Wilcox, who was among this region's earliest teachers. After hostilities concluded in 1865, a new wave of immigrants, many of them German, reached Illinois and settled in Black Oaks and other surrounding communities. Carrying the traditions and beliefs from their previous homes, the new settlers started Lutheran services in 1867, and seven years later Trinity Evangelical Lutheran Church emerged as the first organized congregation in Black Oaks.

Despite a worldwide depression that began in 1873, new commercial structures, such as the first Brandt Tavern, were built along Ninety-fifth Street during the 1870s, expanding the local economy. In November 1879, shortly after the depression lifted, railway entrepreneur Ralph Plumb signed an agreement with residents John Simpson, Charles Simpson, John Simpson Jr., and Franklin Chamberlain that brought a Wabash rail line through Black Oaks. Completed in March 1881, the new track connected the community to the rapidly growing city of Chicago and created a lifeline of transportation and commerce that played a large role in Oak Lawn's development. The following year, the area surrounding Ninety-fifth Street and Cook Avenue was subdivided into lots, streets, and alleys, providing the blueprint for what later became the heart of the village. In addition, 1882 marked the transition from the use of Black Oaks to that of Oak Lawn as the community's official name. In the late 19th century, Oak Lawn, consisting of only a few hundred residents, experienced further growth with the founding of the First Congregational Church in

1891, construction of several small subdivisions, and the completion of Oak Lawn Lake. Each of these events added to the village's shifting landscape, and as the new century approached, significant changes were in store.

On February 4, 1909, residents gathered in Larsen's Hall on Ninety-fifth Street to decide on the issue of incorporation. Due to the development of neighboring communities like Evergreen Park, the need for municipal services, and the perceived threat of an expanding Chicago, many supported the creation of a local government. By a count of 59 in favor to 4 opposed, the vote for incorporation prevailed, and the Village of Oak Lawn was born. Although an election took place on March 9, state law required that a second election be held on April 20, resulting in James Montgomery chosen as mayor and Charles Schultz as clerk. Some of the earliest laws debated by the newly elected government included that no tavern be located within 200 feet of a church or school, and bathers were to dress in a suit covering the body from the shoulders to the knees. Soon after incorporation, Frank O'Brien was hired as the first village marshal, ushering the era of professional law enforcement into Oak Lawn. The following years witnessed numerous improvements, such as the laying of concrete sidewalks, the grading and oiling of Ninety-fifth Street, introduction of gas and electric service, and construction of a village hall near Ninety-fifth Street and Cook Avenue.

As Oak Lawn left the early decades of the 20th century behind, many of the institutions that would help the community flourish came into being. Founded in 1921, the Oak Lawn Volunteer Fire Department worked to protect residents and their property from the threat of fire. St. Gerald, Oak Lawn's first Roman Catholic parish, celebrated its inaugural Mass in December of that same year while new schools, such as Simmons, provided education to a village that, by 1930, expanded to over 2,000 residents. Businesses including the Atlantic & Pacific Tea Company, Behrend's Hardware, and the Standard Oil station lined Ninety-fifth Street, paving the way for further economic growth. During the uncertain days of the Great Depression, Oak Lawn received several Works Progress Administration grants, part of Franklin Roosevelt's New Deal Program, that allowed for the opening of the first library as well as the completion of other projects. In 1933, the long-running *Oak Lawn Independent* commenced its publication, providing up-to-date news and information for residents. As the 1930s came to a close, Oak Lawn started to shed its agricultural roots, undergoing a transformation that radically altered every facet of the village.

In the aftermath of World War II, millions of men and women returned to the United States from military service, looking to find jobs, build homes, and raise families. Oak Lawn was one of thousands of communities across the country to experience massive population growth in the late 1940s and into the 1950s, as an unprecedented amount of Americans moved into the suburbs and spread out from the cities. In 1953, Oak Lawn's population surpassed 13,000, quadrupling its number from a decade before, and subdivisions like Lynwood and Oak Meadows sprung up seemingly overnight. With the burst of new housing, many aspects of government, businesses, schools, and service organizations saw significant changes. During the 1960s, growth continued unabated, and in 1965 nearly 50,000 people called Oak Lawn home. Despite the cleanup and rebuilding effort required after the destructive 1967 tornado, the frantic development lasted into the following decade, affecting every portion of the village. By the 1980s, the small and sparsely populated rural community of years past was gone. In its place stood a bustling and highly developed suburb of over 60,000 residents.

When the rampant growth of the previous decades slowed, community leaders realized that new methods were needed to revitalize the now aging village. Beginning in the 1980s, they looked for ways to renew Ninety-fifth Street and other areas. As part of the strategy, new buildings and parks like the village municipal center, Metra Train Station, community parking garage, and the village green were built, while existing ones received major renovations; however, as a result of the redevelopment, the old village hall, Center of Public Safety, Cook School, Brandt Building, and other structures were demolished. The changes, many of which occurred near Ninety-fifth Street and Cook Avenue, drastically altered the intersections appearance, and it now bears little resemblance to the way it looked just 25 years ago. This incredible transformation makes

the redevelopment of the village a dramatic era in Oak Lawn's history, and one that will have ramifications for decades to come.

Over the last 180 years, the village has grown from a rural community of just a few families to a dynamic suburb of nearly 60,000. The transition to the Oak Lawn known today has been nothing short of spectacular, but it has not been without difficulty. Oak Lawn residents have faced and overcome a number of challenges, including providing quality housing and education, expanding municipal services to meet demand, and recovering from the devastating effects of the 1967 tornado. This adversity forever changed the face of Oak Lawn and also led to some of its greatest success stories. Presently, the village continues to evolve much as it has since its founding over a century ago. Although the landscape has changed dramatically, the accomplishments, failures, triumphs, and tragedies of those early residents remain.

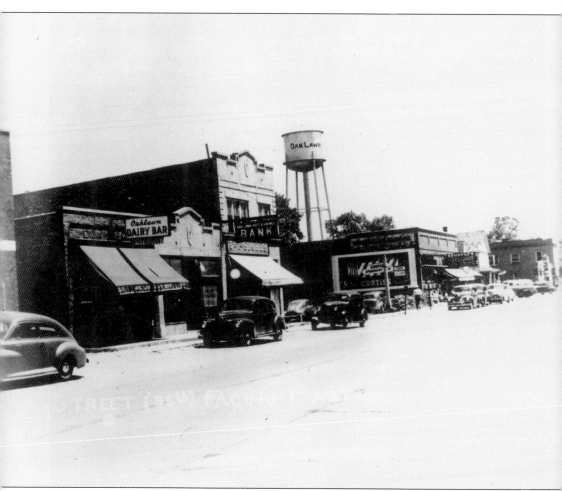

By 1947, Ninety-fifth Street had grown from a narrow dirt road into a bustling thoroughfare lined with buildings. Some of the locations visible on the north side of the street include, from left to right, the Oak Lawn Dairy Bar, Oak Lawn Trust & Savings Bank, water tower, Behrend's Hardware, Hilgendorf House, and Nick's Tavern. (Courtesy of the Oak Lawn Public Library.)

One
BLACK OAKS AND BEYOND

When the first settlers arrived in Black Oaks during the 1840s and 1850s, they found a diverse landscape covered with prairie grass, tree groves, swampland, and a number of different animals. Because of the small population, large distances separated neighbors, and for many years the closest location to purchase supplies and receive medical attention was Blue Island. As time passed, more settlers arrived to build homes, operate farms, and open businesses. In addition to the Simpsons and Chamberlains, other early settlers included members of the Brandt, Harnew, Schussler, O'Brien, and Gaddis families. Many of these men and women played integral roles in the growth of the village, establishing the foundation for the community to come. By the early 20th century, Oak Lawn remained a largely rural settlement of around 300 people. However, important milestones, such as the completion of the Wabash rail line several decades earlier, the development of Ninety-fifth Street, and the formation of a local government in 1909, attracted more residents. America's involvement in World War I, which began in 1917, also impacted the tiny community, drawing both men and women into military service. In the years following the war's conclusion, the United States entered a period of tremendous economic growth. The village benefited from the boom, and new businesses further expanded the local economy. When the stock market crashed in October 1929, Oak Lawn, along with communities nationwide, felt the effects of the spiraling economy. Although the population continued to grow, the village struggled financially, relying on the Works Progress Administration to fund projects and forming a special commission to address the difficulties. As the Depression eased in 1940, Oak Lawn, now home to nearly 3,500 people, entered a new era and stood on the verge of profound changes.

Today's heart of the village, the intersection of Ninety-fifth Street and Raymond Avenue, appeared quite differently around 1912. The first building on the left is Larsen's Hall, the site of Oak Lawn's incorporation in 1909, while a recently constructed Behrend's Hardware is visible on the right. (Photograph by Charles R. Childs; donated to the library by Lucille Gaddis.)

Snapped around 1912, this image captures Ninety-fifth Street looking east near Fifty-third Avenue. On the left, from back to front, are Behrend's Hardware, the Hilgendorf House, Schultz's Store, and Trinity Evangelical Lutheran Church. To the right is Krueger's Meat Market, with the spire of the Brandt Building rising just beyond. Recent improvements, including cement sidewalks and electric light poles, are visible. (Courtesy of the Oak Lawn Public Library.)

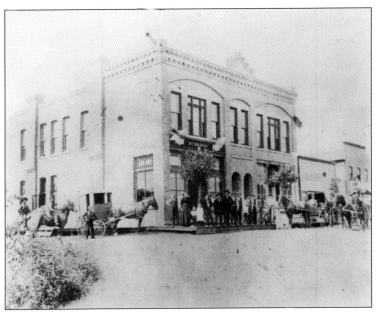

Constructed around 1876 near Ninety-fifth Street and Tulley Avenue, the original Brandt Building housed a popular tavern. It was owned by Wilhelm Brandt, who purchased the business after moving from Blue Island. In 1898, sparks from a coal locomotive set a nearby barn on fire, which spread to the Brandt Building and completely destroyed it. (Courtesy of the Oak Lawn Public Library.)

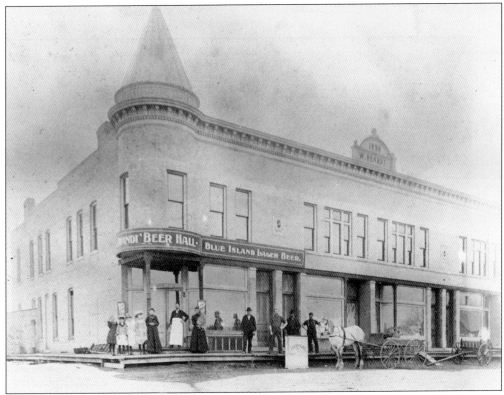

After the first structure was consumed by fire, a new Brandt Building was constructed at the same location on Ninety-fifth Street. Pictured around 1901, it remained a popular spot for decades and was a source of controversy in 1913 when residents attending a dance there fought with intruding Chicago policemen in what became known as the "Battle of Oak Lawn." (Donated to the library by the Oak Lawn Camera Shop.)

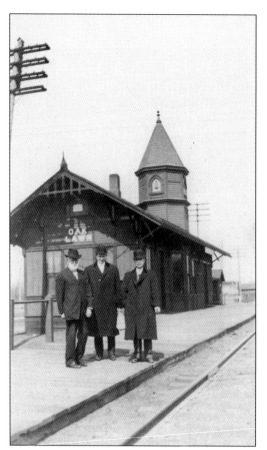

The Wabash rail line, completed in 1881, opened new opportunities for commerce and transportation in the village. This image shows the Oak Lawn Train Depot as it appeared in 1915. From left to right are Enoch Tucker, James A. Tucker, and Harry Thornton. The depot would remain in use until 1953, when it was destroyed by fire. (Donated to the library by Ethel Tucker.)

Located a short distance apart, Cook School and the Oak Lawn Train Depot were among the more prominent village structures in 1910. Completed in 1906, Cook School, then known as the Oak Lawn School, was the first multiroom education building in the village. It opened with two classrooms and Civil War veteran Joseph Covington as the first teacher. (Courtesy of the Oak Lawn Public Library.)

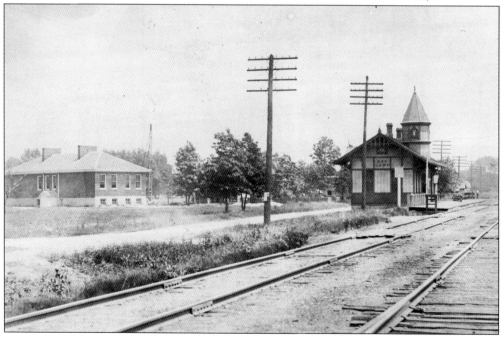

In September 1919, nearly one year after an armistice officially ended World War I, Oak Lawn hosted a welcome-home parade for its servicemen. Barely visible on the left in her white dress uniform is Enid Auschwitz, Oak Lawn's first known female veteran, and walking in the foreground is James Montgomery, the village's first mayor. (Donated to the library by Winifred Reynolds.)

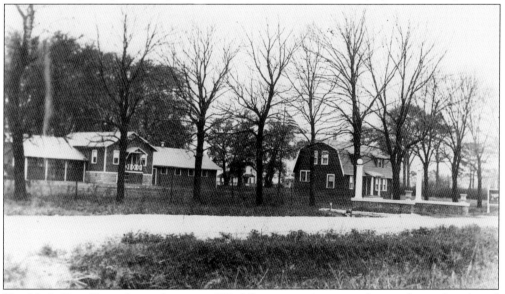

Haedtler's Goat Farm, located on west 103rd Street, was just one of many farms that dotted the Oak Lawn landscape around 1926. The building on the left held goat stalls, and the home on the right belonged to Charles Burger, the farm's manager. (Donated to the library by Arthur W. Haedtler.)

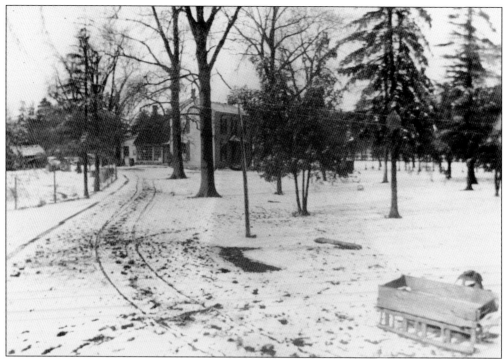

The Evergreen Farm, located near 104th Street and Long Avenue, presents a peaceful winter setting in this 1912 photograph. The farm was owned by Albert L. Van Den Berghen, a well-known sculptor, whose white home can be seen near the center of the picture. (Donated to the library by Harry Fletcher.)

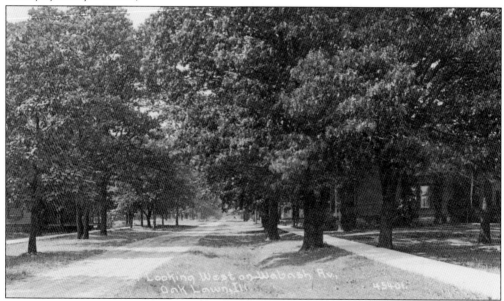

Early in the 20th century, postcards were a popular fad among Americans, and many communities, including Oak Lawn, were featured on them. Shown in this postcard is a still unpaved Wabash Avenue lined with large oak trees, several homes, and recently built sidewalks. (Photograph by Charles R. Childs; courtesy of the Oak Lawn Public Library.)

Dug by Olaf Larsen between 1891 and 1895, Oak Lawn Lake became a source of recreation for many residents, offering fishing, swimming, skating, and a picnic area. Pictured around 1916, the lake had several small islands near its center, and an unpaved West Shore Drive can be seen running along the bank. (Donated to the library by Frank Harker.)

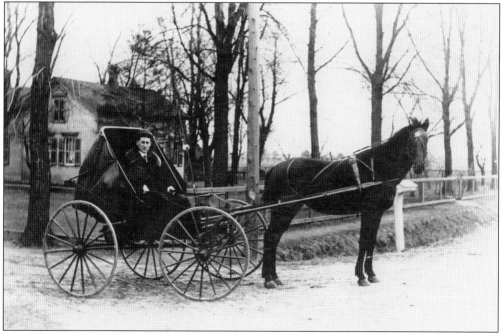

Hans Reimer, an early area resident, is pictured around 1900 in front of the Hilgendorf Farm at 103rd Street and Cicero Avenue. The horse at the head of the buggy was a colt from Blue Mantle, a famed racehorse who ran at the track in Worth, which is now the site of Holy Sepulchre Cemetery. (Courtesy of the Oak Lawn Public Library.)

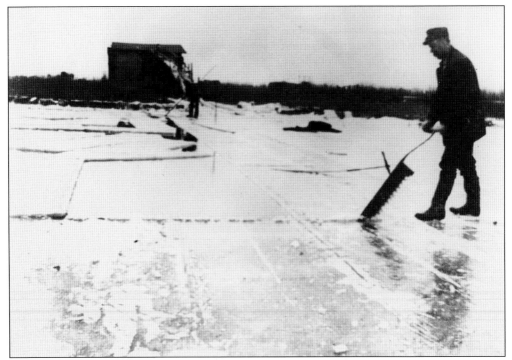

Prior to refrigeration, residents relied on ice to help keep food cool, especially in the warm summer months. In this 1912 photograph, Olaf Larsen cuts ice blocks at the Evergreen Farm near 104th Street and Central Avenue. In the distance is the icehouse, used for storing the blocks awaiting shipment. (Donated to the library by Harry Fletcher.)

Arriving in Oak Lawn around 1860, the Harnew family is counted among the earliest settlers to the area. The family's home, located at Ninety-eighth Street and Central Avenue, is pictured here in 1888. From left to right are Sarah Harnew Justice, Mary Harnew, Ida Justice, Ellen Harnew, William Harnew Sr., and William Harnew Jr. (Courtesy of the Oak Lawn Public Library.)

Taken around 1914, this photograph shows O'Brien family members near their home on Fifty-third Court. Standing to the far left is Frank O'Brien, who served as Oak Lawn's first village marshal. The others are, from left to right, (first row) William O'Brien and Emmett O'Brien; (second row) Raymond O'Brien, Marie O'Brien, and William O'Brien. (Courtesy of the Oak Lawn Public Library.)

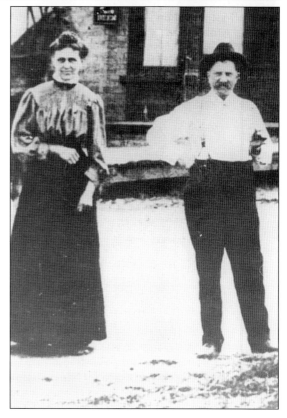

Wilhelmina Brandt (left) and Wilhelm Brandt pose proudly in front of their tavern on Ninety-fifth Street around 1900. Wilhelm also operated a blacksmith shop, and he and his wife were members of Trinity Evangelical Lutheran Church. The couple remained actively involved in the community until passing away in 1926 and 1927, respectively. (Courtesy of the Oak Lawn Public Library.)

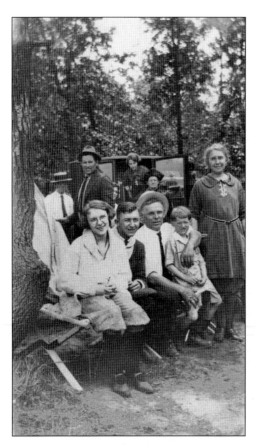

Pictured around 1919, the Phillips family enjoys one of Oak Lawn's many picnic groves. From left to right are (first row) Hazel Phillips, Eddie Priller, Harry Phillips, Jimmy Tucker, and Laura Phillips; (second row in an unknown order) Mr. Collins, Jim Tucker, and Mrs. Collins. (Courtesy of the Oak Lawn Public Library.)

Standing in front of their parents' home on Minnick Avenue, the Aulwurm brothers pose stoically for the camera. From left to right are Alfred Aulwurm, Irvin Aulwurm, and Arthur Aulwurm. Alfred's son Alfred Jr., who went on to become a well-known musician and conductor, played with the Glenn Miller Orchestra during World War II. (Donated to the library by Ella Aulwurm.)

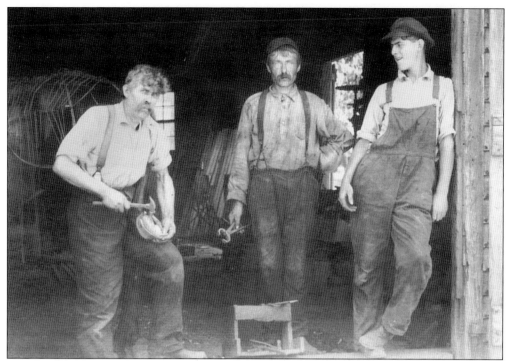

Leaving Russia for the United States in 1889, Leo Hoffman was one of many immigrants who arrived in Oak Lawn during the late 19th century. A blacksmith by trade, he opened a business on Minnick Avenue near Ninety-fifth Street. Working in the shop around 1913 are, from left to right, Leo Hoffman, unidentified, and George Hoffman. (Donated to the library by Joan Hoffman.)

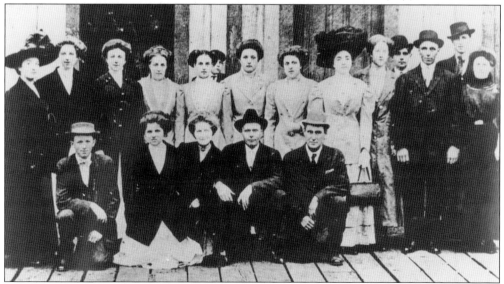

Gathered for a Sunday trip, a group of residents waits in front of the Oak Lawn Train Depot in 1910. From left to right are (first row) Elmer Sahs, two unidentified, Bill Evers, and George Beebe; (second row) Frieda Kurth, Lillian Lange, Lydia Sahs, Minnie Schultz, Clara Lange, unidentified, Elizabeth Lange, Elizabeth Schultz, Minnie Kurth, Irene Sahs, Clifford Krueger, William Kurth, Otto Brandt, and Augusta Brandt. (Courtesy of the Oak Lawn Public Library.)

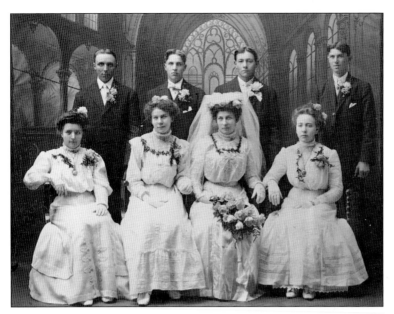

Professional wedding photography was still in its infancy when this photograph was taken around 1900. From left to right are (first row) Elizabeth Lange, Ella Lange, Emma Lange, and Minnie Braasch; (second row) William Kurth, Albert Schultz, Gottfriend Braasch, and Otto Brandt. (Courtesy of the Oak Lawn Public Library.)

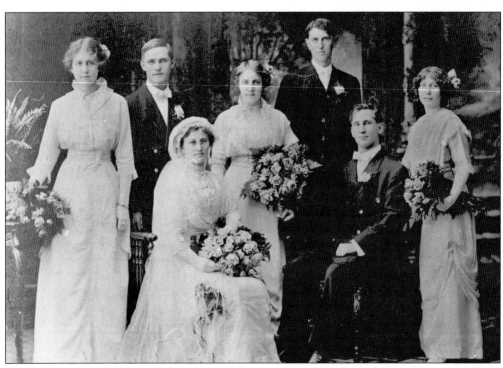

The bridal party of Nicholas Schmalen and Augusta Brandt sit for a photograph around 1900. From left to right are Anna Hoffman, Henry Schmalen, Augusta (Brandt) Schmalen, Wilhelmina Schultz, Otto Brandt, Nicholas Schmalen, and Elizabeth Schmalen. (Courtesy of the Oak Lawn Public Library.)

Two

Faith and Worship

Over the course of its history, Oak Lawn has been home to a number of different religious denominations. Trinity Evangelical Lutheran, First Congregational, First Christian Reformed, Methodist Episcopal, and St. Gerald are among the earliest churches in the area, providing a spiritual outlet and gathering place for residents. Although numbers grew steadily in the years prior to World War II, the village's population explosion, occurring in the late 1940s and beyond, led to a number of new parishes and congregations entering Oak Lawn. With thousands of people arriving each year, faith communities were needed to meet the spiritual and social demands of Oak Lawn residents. Consequently, newly created churches, as well as others originally founded in nearby communities, moved into the village at a rapid pace. St. Paul Lutheran, St. Raphael the Archangel, St. Linus, Green Oak Reformed, Christ Memorial, and many others became a part of the fabric of Oak Lawn, providing education and working to serve the developing village. They also played important roles in events such as the 1967 tornado, contributing food, clothing, and shelter to assist the victims. With the influx of new residents, many of them coming from a Roman Catholic background, Oak Lawn saw a shift from a community of mostly Protestant followers to one of greater religious diversity. This transition reshaped Oak Lawn, creating new dynamics and relationships in the village. As the rapid growth faded and the population stabilized, churches around the village adapted to the changing needs of their followers. Even now, these institutions continue to be a source of strength and pride in the community, providing invaluable services to an increasingly varied population.

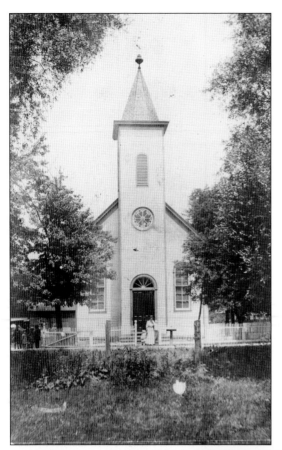

Formally organized in 1874 by German settlers, Trinity Evangelical Lutheran Church is the oldest congregation in the village of Oak Lawn. Its first structure, pictured here around 1900, was located on Ninety-fifth Street near the Wabash Railroad tracks. The congregation had a small school located behind the church. (Courtesy of the Oak Lawn Public Library.)

By the time of this 1927 Confirmation photograph, Trinity Evangelical Lutheran Church had been active for over 50 years. From left to right are (first row) Elsie Dueshop, unidentified, Pastor Prange, unidentified, and ? Graefen; (second row in an unknown order) Harland Rubeck, Clarence Benck, Harold Plum, Ray Termunde, and Bill Termunde. (Courtesy of the Oak Lawn Public Library.)

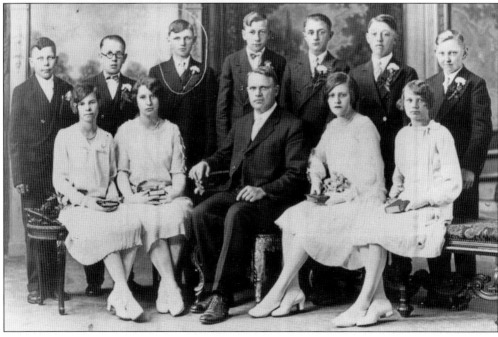

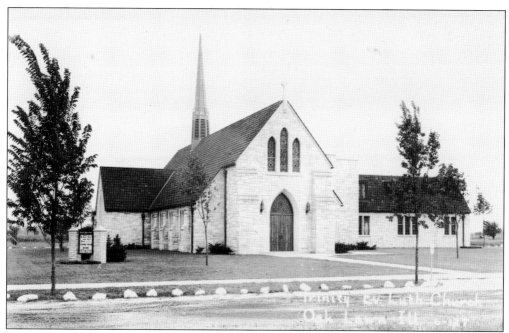

Due to a growing congregation that reached nearly 500 baptized members in 1940, Trinity Evangelical Lutheran Church moved to a new building located near Brandt Avenue and Ninety-seventh Street. This image shows the recently completed church as it appeared around 1941. (Courtesy of the Oak Lawn Public Library.)

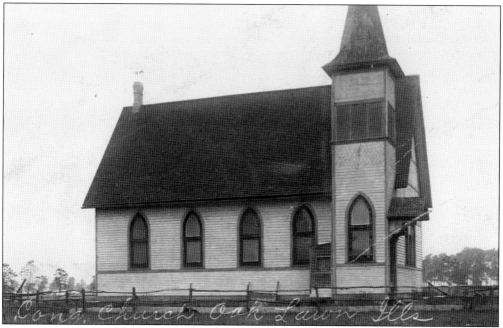

Built in 1892 on land donated by Charles Simpson, the First Congregational Church, located on Fifty-fourth Avenue, is pictured around 1900. Many early settlers, including members of the Sproat, Harnew, and Simpson families, were part of the congregation. The building still stands, although it has been a private residence since 1951. (Courtesy of the Oak Lawn Public Library.)

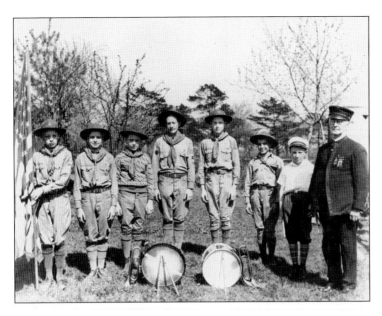

Since its founding in 1910, the Boy Scouts of America have played an important role in many communities across the United States. Pictured in 1929, the scouts of the First Congregational Church stand at attention. From left to right are Thomas Watson, Joseph Meyer, Austin DeVane, Thomas Malmer, James Rathje, Leo DeRuntz, Henry Malmer, and Major Torey. (Courtesy of the Oak Lawn Public Library.)

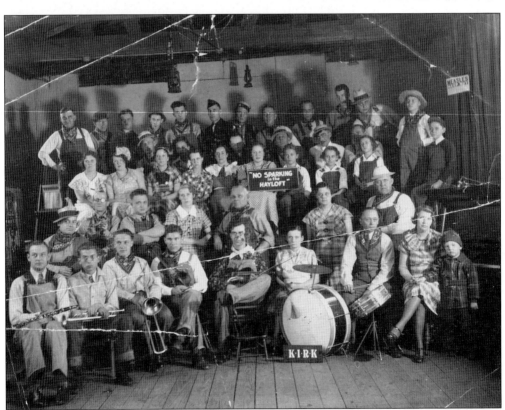

The appropriately dressed cast of First Congregational Church's "Barn Dance Show" prepare for its next performance in 1935. Sponsored by the Men's Club, the program was used as a fundraiser to construct a new annex for the church. (Courtesy of the Oak Lawn Public Library.)

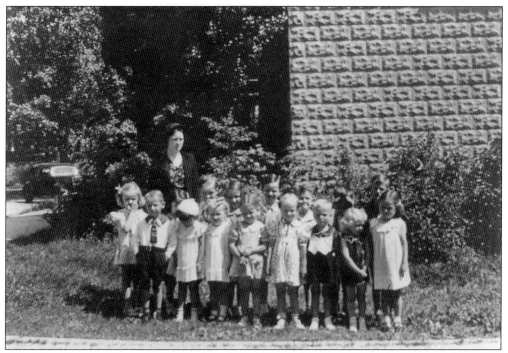

First Congregational was one of several churches in the village that ran a Sunday school program for younger members. Taken around 1938, this photograph shows the preschool class posing outside of the church on Fifty-first Avenue. Standing toward the back, behind the children, is teacher Bettie Schaller. (Donated to the library by Katherine Trimble.)

The Oak Lawn Methodist Episcopal Church opened in 1902 on Minnick Avenue and peaked with just 12 members in 1912. By the time this picture was taken around 1927, another congregation, the Protestant Reformed Church, had moved in. Looking much as it did a century ago, the building is currently home to the Disciples for Christ. (Courtesy of the Oak Lawn Public Library.)

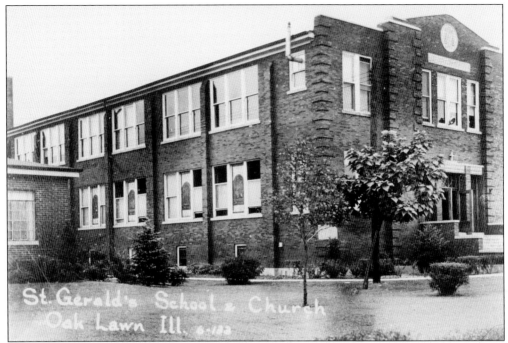

Celebrating its first Mass on Christmas Day in 1921, St. Gerald is the oldest Roman Catholic parish in Oak Lawn. After holding services in several different locations, permanent school and church buildings were completed in 1929 near Ninety-fourth Street and Central Avenue. Pictured around 1947, the first floor served as a church, while the second story housed classrooms. (Donated to the library by William Umofer.)

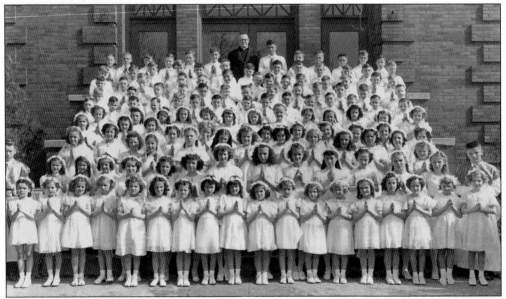

Over 100 First Communicants pose outside of St. Gerald in this 1947 photograph. In the late 1940s, St. Gerald, much like the village itself, was growing at a rapid pace. Just two years after this photograph was taken, a large addition to the school was completed. (Photograph by Arthur P. Stalla; donated to the library by Elaine Hicks.)

In 1956, St. Gerald embarked upon a massive expansion that included a new church, additional classrooms, and updates to the convent and rectory. Presiding over the cornerstone ceremony are the Reverend Edward O'Brien (left) and the Reverend Loras Welsh (right). Assigned in 1934, the Reverend Welsh served as St. Gerald's pastor until a car accident claimed his life in 1958. (Donated to the library by Mary Lou Harker.)

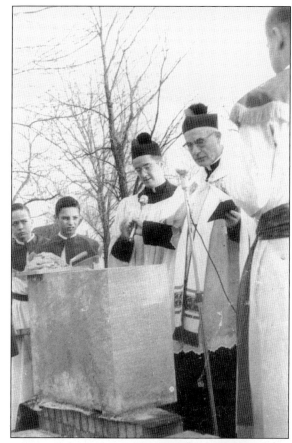

Monsignor William McNichols began his service at St. Gerald in 1958 and helped guide the parish through several decades of rapid growth and change. In 1978, the church marked his 65th birthday and the 40th anniversary of his ordination with a large celebration. Monsignor McNichols is holding the village flag, while Mayor Ernie Kolb stands to the right. (Donated to the library by Mary Lou Harker.)

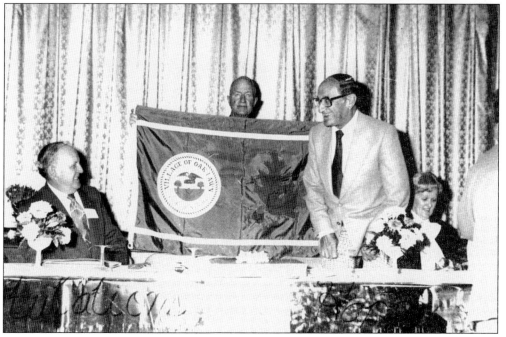

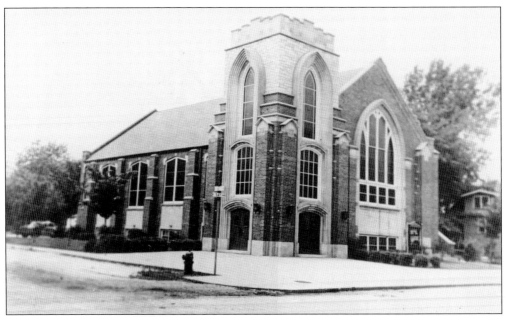

The Oak Lawn Christian Reformed Church officially organized in 1913 with 16 families. After outgrowing their first home on Fifty-fourth Avenue, the congregation constructed a new building one block north near Ninety-fourth Street. This photograph, taken around 1951, shows the recently completed church. (Courtesy of the Oak Lawn Public Library.)

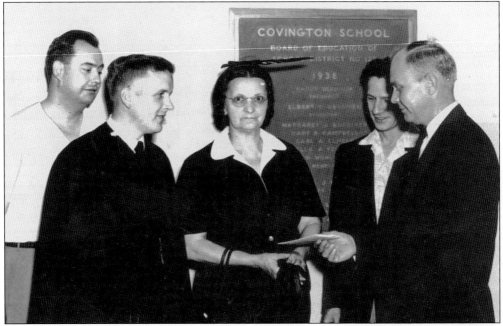

In 1952, St. Paul Lutheran received a gift of land to build a new church near Ninety-fourth Street and Kilpatrick Avenue. The deed, donated by Martha Fenzau, was presented to members of the church at Covington School. From left to right are Alvin Puder, the Reverend Delwyn B. Schneider, Martha Fenzau, Delwyn Burandt, and Marvin Schurke. (Courtesy of the Oak Lawn Public Library.)

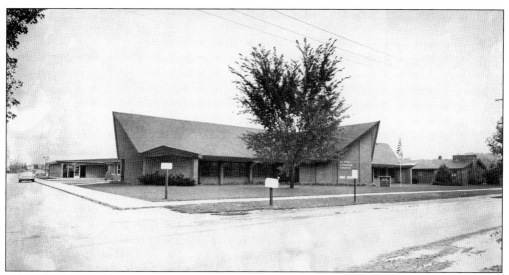

Dedicated in September 1954, the new church was completed nearly six years after St. Paul Lutheran held its first services. By the time this photograph was taken around 1965, it had grown substantially with the opening of an education building and further additions to the church. (Courtesy of the Oak Lawn Public Library.)

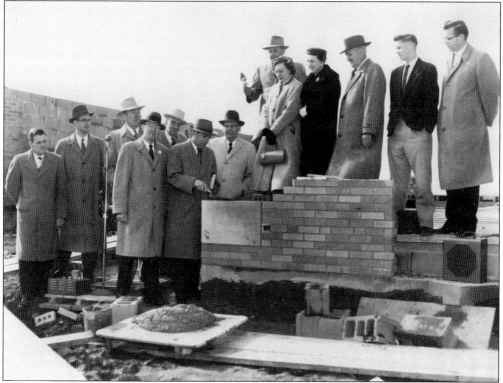

Originally located in Chicago, Elim Evangelical Free Church moved to Oak Lawn in 1955. Initially meeting in McDonald School, the church began Sunday school classes soon after its arrival. Two years later, in October 1957, the congregation laid the cornerstone for its new home near 100th Street and Kostner Avenue. (Courtesy of the Oak Lawn Public Library.)

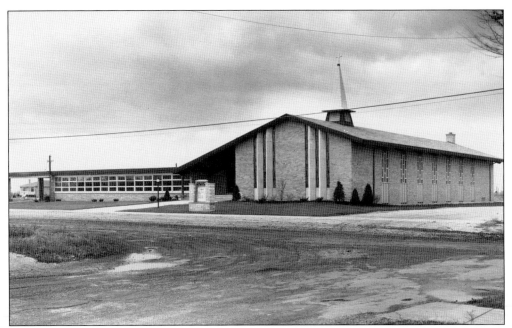

Taken around 1958, this photograph shows the recently completed Elim Evangelical Free Church at the corner of 100th Street and Kostner Avenue. In the following years, the church expanded with its congregation and continues to serve today. (Courtesy of the Oak Lawn Public Library.)

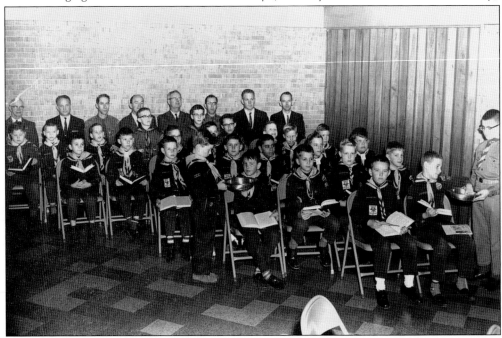

Members of Garden Methodist Church, located at 100th Street and Central Avenue, observe "Scout Sunday" in this 1965 photograph. Organized in 1957, Garden Methodist was just one of several churches that moved into Oak Lawn during the 1950s. In 1975, the congregation merged with Redeemer Methodist of Evergreen Park, and today its name is the First United Methodist Church of Oak Lawn. (Courtesy of the Oak Lawn Public Library.)

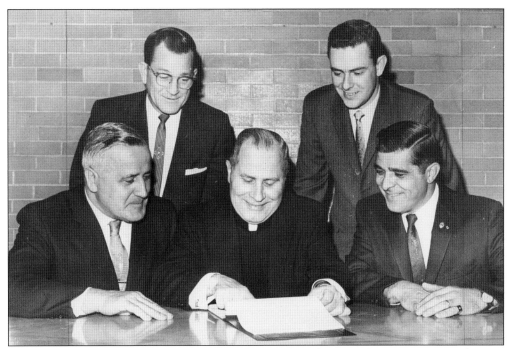

Meeting in 1964, members of the St. Louis de Montfort Planning Committee are working to finalize an expansion that would take place the following year. From left to right are (first row) Dennis Mulcahy, Fr. James C. Quinn, and Louis Rossi; (second row) Richard Strick and Robert Coyle. (Courtesy of the Oak Lawn Public Library.)

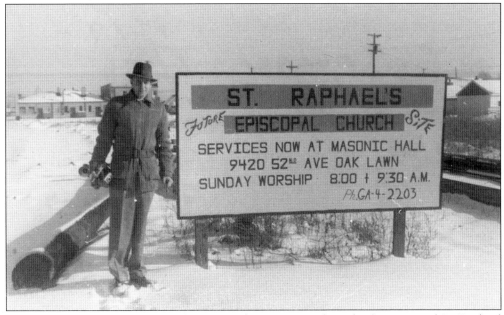

Pictured around 1959, senior warden Leonard Pearson stands at the future site of St. Raphael the Archangel Church on Forty-ninth Avenue. Until the new building was completed, services were held at Harnew School and, later, moved to the Oak Lawn Masonic Hall. (Courtesy of the Oak Lawn Public Library.)

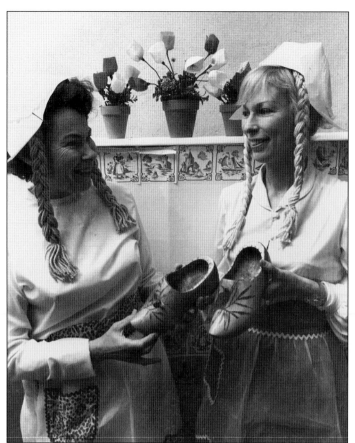

Featuring a Dutch theme, this is the St. Raphael the Archangel's annual spring luncheon in 1975. The event was a fundraiser for the church and drew capacity crowds. Pictured in costume are Betty Smolinski (left) and Karen Moan. (Photograph by David Mena; courtesy of the Oak Lawn Public Library.)

Pilgrim Faith United Church of Christ came about with the merging of several different churches, including the First Congregational of Oak Lawn. The current building on Fifty-first Avenue, pictured here in 1990, was constructed in 1949 and has undergone several additions. (Courtesy of the Oak Lawn Public Library.)

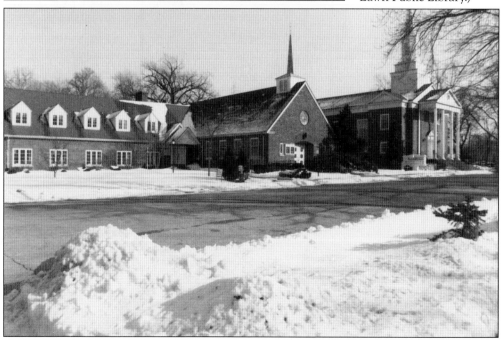

Three

SCHOOL DAYS

During the 19th century, simple one-room buildings were the only schools available for Oak Lawn children. As new residents arrived, more space was needed, resulting in the construction of Cook School in 1906, Simmons School in 1923, and Covington School in 1938. With the population growth that began in the late 1940s, far more classrooms were required, and a large building program ensued. Sward, Hometown, George W. Lieb, Clark, and Kolmar were all constructed to accommodate the thousands of families arriving each year. In addition, older buildings, such as Simmons and Covington, received significant upgrades. Along with the public system, a number of private schools, including St. Paul Lutheran and St. Louis de Montfort, were built, while older institutions underwent extensive renovations. By the early 1970s, the village had parts of seven different school districts within its borders and counted an enrollment of nearly 25,000 students from Oak Lawn and other nearby communities. District No. 123, the largest in the village, saw its student population grow from 1,200 in 1950 to nearly 7,000 in 1970; however, in the following decades, the number of enrolled students declined sharply. Oak Lawn Community High School, which supported nearly 2,800 students in 1972, saw that number drop to just over 1,400 near the end of the 1980s. This trend continued as fewer families arrived in the area, and several institutions were closed during this time. Today, the village's schools, adapting to a changing population and the impact of advancing technology, educate new generations of students, building on traditions that began over 150 years ago.

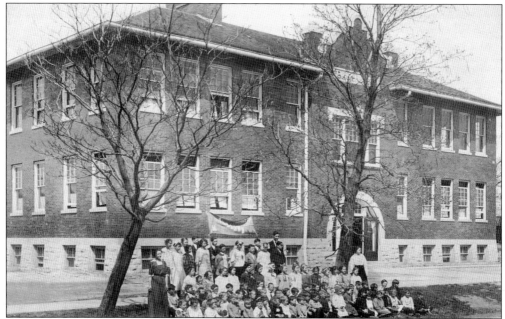

The students and faculty of Cook School stand under a District No. 123 banner in this 1915 photograph. Shortly before it was taken, the building received a second-story addition that doubled its size. On the far left is teacher Hazel Schussler, and on the right is teacher Mary McKeown. Principal Roy Day can be seen standing in the back row. (Photograph by J.M. MacFadyen; donated to the library by Elsie Elvidge.)

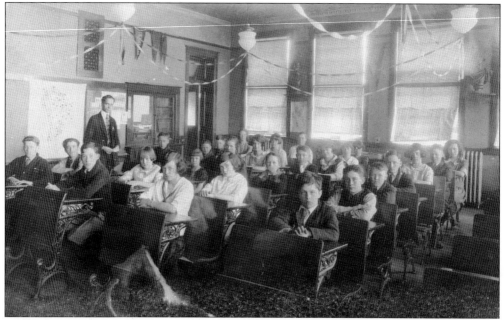

Arriving in 1921, Wiley Simmons came to Oak Lawn after accepting a principal and teaching position at Cook School. Along with his wife, Pearl, Wiley taught at the school for several years before leaving for District No. 122. Taken around 1923, this image shows Wiley with Cook School's eighth-grade class. (Donated to the library by Elsie Elvidge.)

Posing in 1937, the faculty of Cook School had grown steadily since the school opened with just one teacher in 1906. From left to right are Jessica Gault, Cheryl Auschwitz, Jeanette Lawrence, Dorothy Beckley, Mary Walker, Lydia Kobick, Margaret McNellis, Margaret Lambright, and Principal Carl A. Sward. (Courtesy of the Oak Lawn Public Library.)

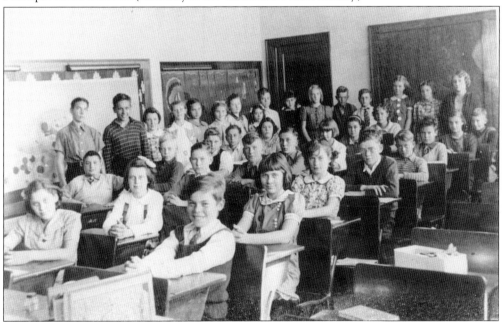

Completed in 1923, School District No. 122, later renamed Simmons School, opened with two classrooms, two teachers, and outdoor restrooms. Several years later, Wiley and Pearl Simmons were hired and remained the school's only educators until the mid-1930s. This 1937 photograph shows students posing in one of the classrooms. (Donated to the library by Winnifred Koszyk.)

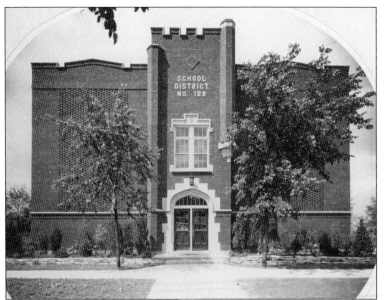

When an alternate name was needed for School District No. 122, the eighth-grade class submitted the suggestions of MacArthur and Simmons to the local school board. After much discussion, they chose the name Simmons, and the school was officially rededicated in 1942. (Courtesy of the Oak Lawn Public Library.)

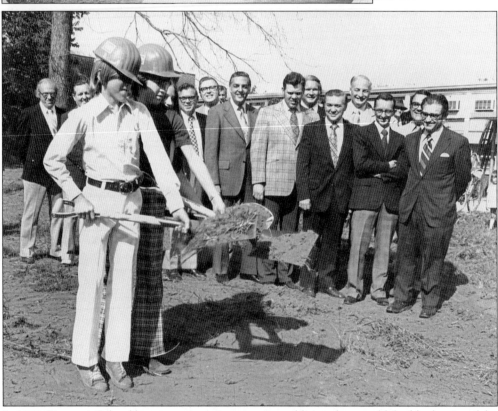

In 1974, Simmons School began construction on a new addition that would double the size of the current building. A ground-breaking ceremony, attended by faculty members and students, was held to commemorate the event. Completed the following year, the new facilities added much needed classrooms but also resulted in the demolition of the original brick structure. (Photograph by Harry Thiem; courtesy of the Oak Lawn Public Library.)

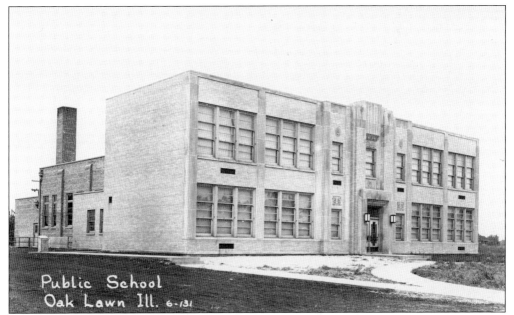

Built toward the end of the Great Depression, Covington School was completed in 1938 with the assistance of a Works Progress Administration grant. Pictured here in the early 1940s, it is named after Joseph Covington, one of Oak Lawn's earliest teachers and a friend of Abraham Lincoln. (Courtesy of the Oak Lawn Public Library.)

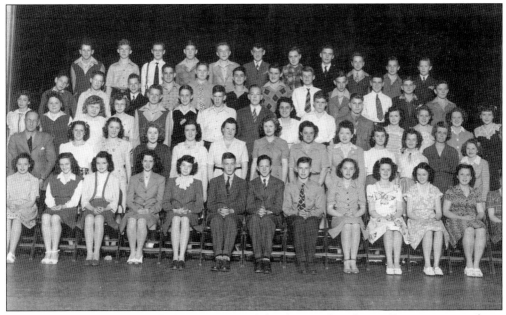

There were 178 students enrolled in Covington School in 1945, and over 60 went on to graduate that year. In the following decades, as Oak Lawn's population soared, the number of students rose dramatically, and several additions were needed to keep pace with the growth. (Courtesy of the Oak Lawn Public Library.)

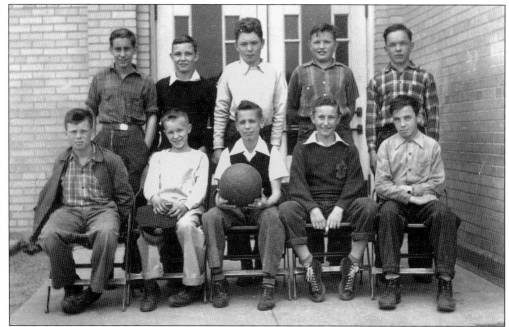

Fresh off a championship, the 1946 Covington School boys' basketball team takes time for a group photograph. Bill Salpacka, sitting in the first row second from the left, is the only identified player. Although basketball was a well-established game by the 1940s, many of the rules would be unfamiliar today. (Donated to the library by John Salpacka.)

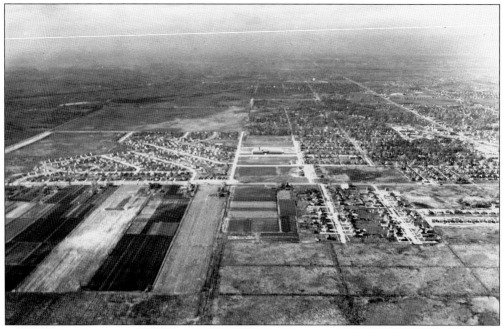

This 1953 aerial photograph offers a bird's-eye view of the area around Ninety-ninth Street and Cicero Avenue. Directly in the center is Sward School, which had been dedicated the previous year, and to the left is the recently completed Oak Meadows subdivision. (Photograph by George R. Balling; courtesy of the Oak Lawn Public Library.)

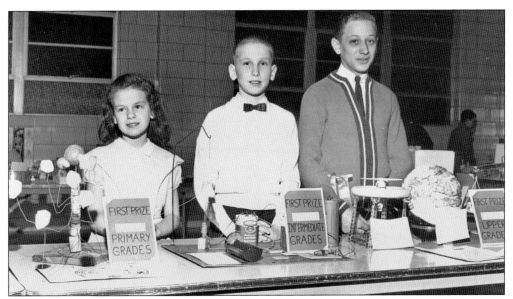

The first-place winners of the 1963 Harnew School Science Fair proudly stand next to their prize experiments. From left to right are Tracy Bishop, David Chaney, and John Body, who represented the primary, intermediate, and upper grades of Harnew School. (Courtesy of the Oak Lawn Public Library.)

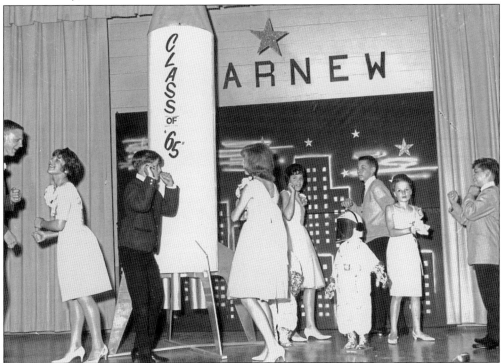

During the peak of the "space race" between the United States and the Soviet Union, images of space travel seemed to be everywhere. In 1965, graduates from Harnew School attended a dance that featured a large model of a rocket ship and even figures of astronauts. (Photograph by Don Weinzierl; courtesy of the Oak Lawn Public Library.)

After opening in 1958, Gasteyer School quickly became one of the cornerstones of Oak Lawn's growing education system. As the number of students rose, the school received several renovations, including the installation of new playground equipment in 1962. (Photograph by Don Weinzierl; courtesy of the Oak Lawn Public Library.)

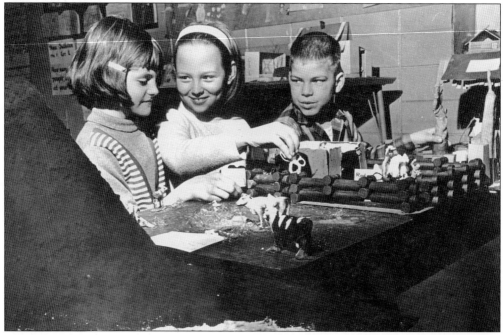

In 1966, Gasteyer School hosted a large fair that featured creative projects submitted by students. Using items such as Lincoln Logs and toy figures, these children created a model of a Western fort. From left to right are Leanne De Haan, Vicki Lobbes, and Jim Snider. (Photograph by Gene Pahnke; courtesy of the Oak Lawn Public Library.)

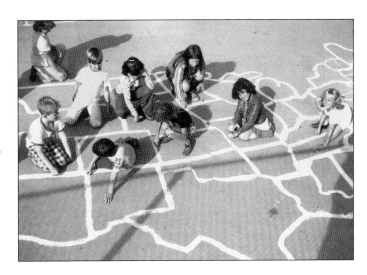

Using the playground blacktop as their canvas, students from Dearborn Heights School, now known as Kolb, paint a map of the United States in 1975. From left to right are (first row) Jim Sexton, Jon Ward, Elaine Framberg, Michelle Wennersten, and Robbin Fleishman; (second row) Lynn Hardt, Tony Ratcliff, Michele Beauvais, and Janine Tarnowski. (Courtesy of the Oak Lawn Public Library.)

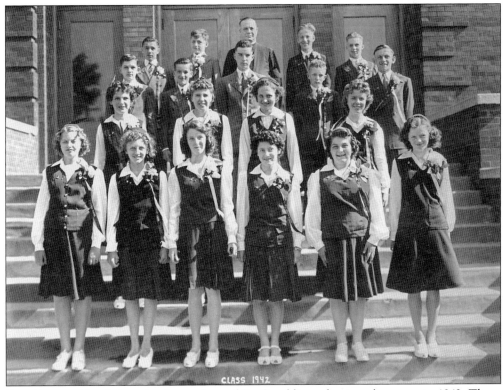

Standing outside of the school, members of St. Gerald's graduating class pose in 1942. Those who can be identified are (first row, second from right) Geraldine De Runtz; (third row, from left to right) Ardwin Bayer, Edward Ulatoski, John McIlvain, James McAninch, and Robert Beyer; (fourth row, from left to right) Richard Evans, unidentified, Fr. Loras Welch, unidentified, and George Palmer. (Donated to the library by Lillian McAninch.)

After the original building was destroyed in the 1967 tornado, St. Gerald completed a new school in September 1968. The rebuilding effort, led by Monsignor William McNichols, added 24 new classrooms and remodeled the damaged rectory. (Courtesy of the Oak Lawn Public Library.)

St. Linus School opened in the fall of 1956 with 208 students, less than one year after the parish was established. By 1965, well over 1,000 children were attending classes at the school, and dual sessions were held for some grades. (Courtesy of the Oak Lawn Public Library.)

St. Louis de Montfort School was still under construction at the time of this 1965 photograph. Completed later that same year, the school opened with nine staff and over 300 students, but only grades three through five were taught. It was not until 1972 that additional grade levels were added to the program. (Courtesy of the Oak Lawn Public Library.)

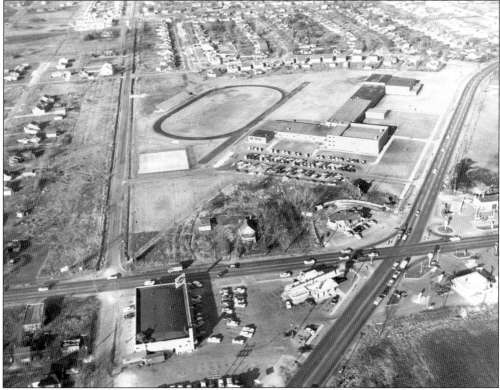

The intersection of Ninety-fifth Street and Southwest Highway looked quite different in 1957. Oak Lawn Community High School is visible near the top right, sitting just north of Ninety-fifth Street. Prior to its opening in 1952, residents commonly traveled to Chicago, Blue Island, or other nearby cities to attend high school. (Courtesy of the Oak Lawn Public Library.)

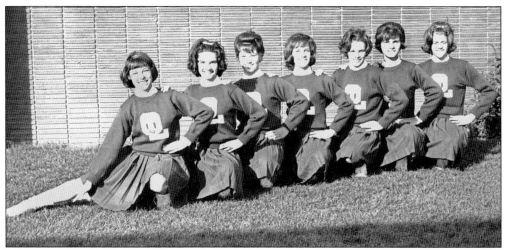

Taken in 1965, the Oak Lawn Community High School freshman and sophomore cheerleading squad poses for a group photograph. From left to right are Mary Ellen Hart, Lynda Jimo, Linda Raap, Darlene Daniels, Terry Hafk, Sue Wettergren, and Elaine Franzen. (Courtesy of the Oak Lawn Public Library.)

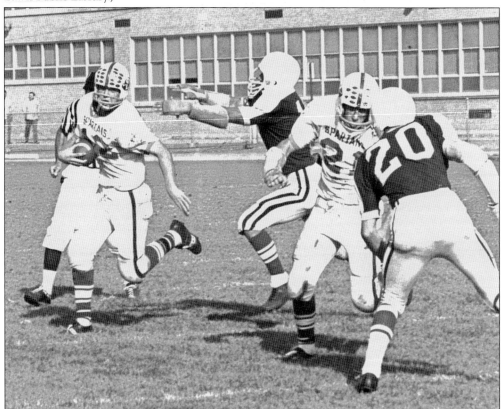

Oak Lawn Community High School quarterback Skip Sullivan races past the opposing defense in this 1968 photograph. An excellent athlete who played football, baseball, and basketball, Sullivan passed for over 3,000 yards in his career at Oak Lawn. In 1973, he began teaching at the school and, later, coached the baseball team. (Courtesy of the Oak Lawn Public Library.)

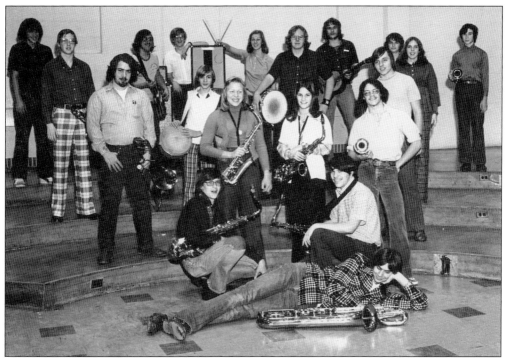

Founded in 1960, the Oak Lawn Jazz Festival was an annual event held at Oak Lawn Community High School. Numerous juniors and seniors from around Chicagoland participated in the contest, which featured musical selections from the Beatles to big band numbers. This 1975 photograph shows the Oak Lawn Community High School jazz band preparing for the competition. (Courtesy of the Oak Lawn Public Library.)

Construction of Richards High School began in 1964, and the building opened the following year. Named after a longtime superintendent of District No. 218, Richards was built during the height Oak Lawn's population explosion and helped to relieve pressure on neighboring schools. (Photograph by Don Weinzierl; courtesy of the Oak Lawn Public Library.)

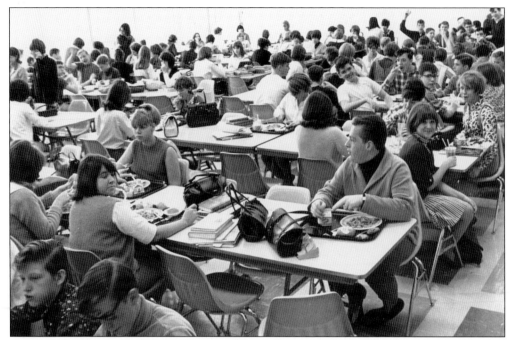

A crowded cafeteria in the Northeast Building of Richards High School is photographed in December 1966. When the school first opened, it participated in the "Two-Two" plan, which separated lower grades and upperclassmen into different buildings. (Courtesy of the Oak Lawn Public Library.)

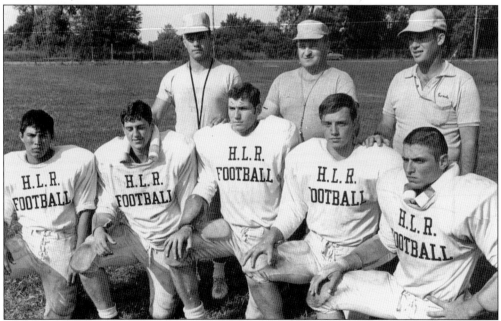

Players and coaches of the Richards High School football team take a break from practice in 1968. From left to right are (first row) George Loera, Dave Brown, Brad White, Bruce Sindewald, and Nick Massarella; (second row) Greg Vock, Ed Murphy, and Harry McDaniel. (Courtesy of the Oak Lawn Public Library.)

Four
BUILDING A COMMUNITY

As the village's population increased, the need for more social partnerships, additional parks, greater access to education, and improved health care became apparent. Many institutions, both public and private, were created to fill the growing demand. Among the most impactful, service clubs, such as the VFW, Elks, chamber of commerce, and the rotary, sprung from every corner of the community. Attracting thousands of members, these organizations saw a surge in membership during the building boom following World War II. Their contributions through fundraisers, awareness campaigns, donations, and other means greatly benefited Oak Lawn. Along with private clubs, public institutions like the Oak Lawn Park District and library have played a large role in the village, offering residents the opportunity for further education, sporting events, and other activities. The park district, organized in 1944, expanded tremendously after its founding. Today, it manages hundreds of acres of green space, playgrounds, and recreation facilities around Oak Lawn. In addition, the library has served countless patrons since opening in 1936 during the uncertain days of the Great Depression. Adapting to the needs of the community, it grew in both size and scope over the last seven decades. Christ Community Hospital, built in the early 1960s, has also been an integral part of the village treating many residents, including those injured during the 1967 tornado. Even now, the hospital is Oak Lawn's largest employer and continues to develop well beyond its original vision. These organizations, along with many others, form and strengthen the overall foundation of the village, providing invaluable opportunities and services.

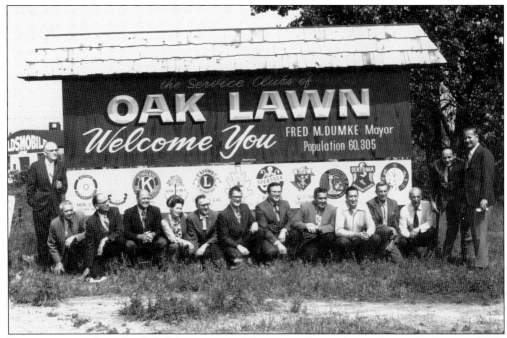

Representatives from the Oak Lawn service clubs pose in front of a newly installed sign in 1971. From left to right are Jack Walker, Warren Schieske, Frank Benedix, Jerry Eastman, Dottie Olsen, W.C. Martschinke, Joe McGee, Richard Jouza, Joseph Butkus, Nathan Grossman, Frank H. Wally, Joseph F. Donofrio, Mayor Fred M. Dumke, and Frank Boblak. (Courtesy of the Oak Lawn Public Library.)

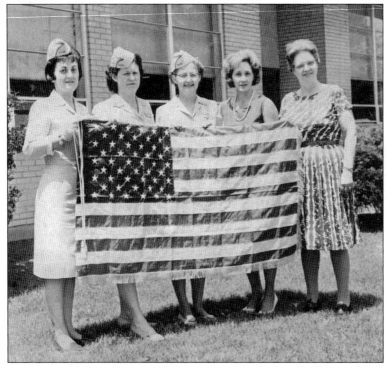

Formed by returning World War II veterans, the Johnson-Phelps VFW and its Ladies Auxiliary organized in 1946. Among its many contributions to the community were the auxiliary presented flags to local schools, including the one to Harnew here in 1965. From left to right are Jean Zemail, Dorothy Hejl, Lucille Pershau, Mildred Dawkins, and Gladys Baldwin. (Courtesy of the Oak Lawn Public Library.)

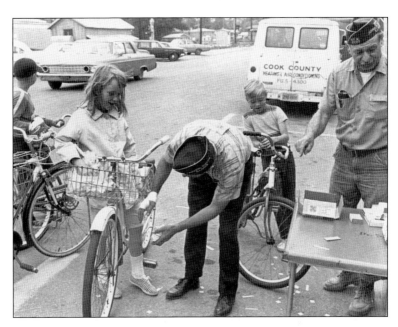

The Johnson-Phelps VFW has sponsored numerous community events, including "Lite-a-Bike." Held in July 1969, this program encouraged children to have their bikes inspected and registered with the village. Hundreds of bikes were brought to the VFW Hall, and the successful campaign continued for several years after. (Courtesy of the Oak Lawn Public Library.)

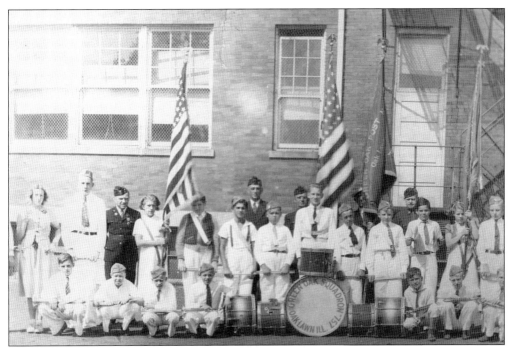

Started in 1934, the Green Oak American Legion was organized by veterans of World War I and met initially at Brandt's Tavern on Ninety-fifth Street. Pictured here around 1940 near Cook School, the post featured a children's drum and bugle corps that performed at memorials, dedications, and other events. (Courtesy of the Oak Lawn Public Library.)

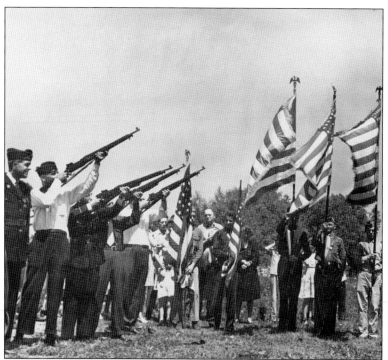

During World War II, the Green Oak American Legion attended funeral services for soldiers who died in the conflict. After the war's conclusion, the Green Oak Post continued to provide veterans with graveside honor guards like the one in this 1949 photograph. (Courtesy of the Oak Lawn Public Library.)

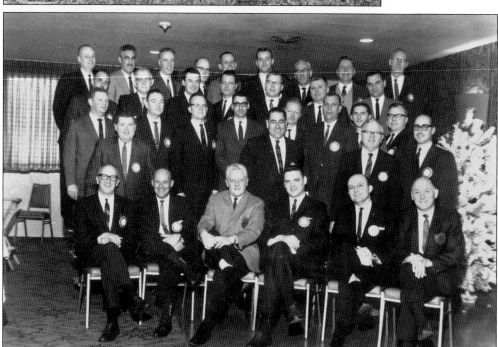

Members of the Oak Lawn Rotary Club pose for a group photograph in December 1966. Founded five years prior, the organization had already made a positive impact in the community by supporting the Garden School for the Handicapped, purchasing flags for display along Ninety-fifth Street, and holding a number of fundraisers. (Photograph by Don Weinzierl; courtesy of the Oak Lawn Public Library.)

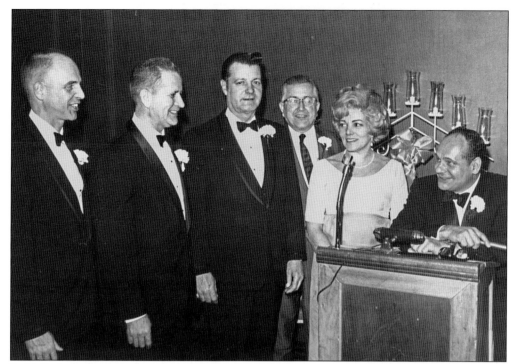

In 1967, the Oak Lawn Chamber of Commerce held its 21st annual officer installation dinner at Jack Kilty's Restaurant on Ninety-fifth Street. From left to right are Louis Kole Jr., unidentified, John Spicer, Walter Malleck, Betty Gallo, and Mayor Fred M. Dumke. (Courtesy of the Oak Lawn Public Library.)

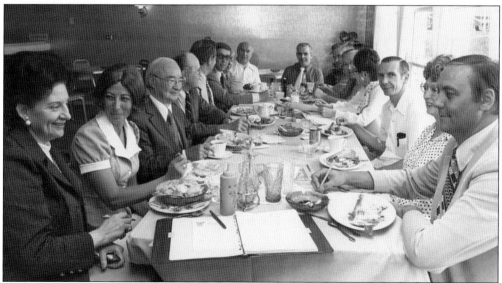

The Oak Lawn Chamber of Commerce plans a Country-Western hoedown at this 1974 luncheon. Clockwise are, starting from the front left, Mary Lotz, Sandy Dorgan, Al Schmitz, Gene O'Reilly, Frank Boblak, Lyle Brooks, Joyce Andersen, Heinz Gliege, Milt Andersen, Bob Nelson, Walter Malleck, Dottie Olsen, Jim Buschbach, Eleanor Barrett, and Tom Davis. (Photograph by Gene Pahnke; courtesy of the Oak Lawn Public Library.)

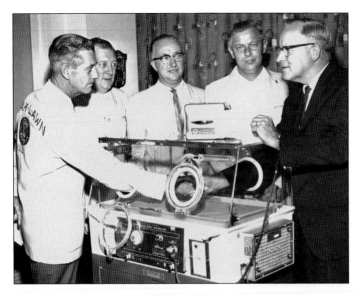

Chartered in 1939, the Oak Lawn Lions Club is among the oldest service organizations in the village. Since its founding, it has supported many causes, including the Boy Scouts, the Young Men's Christian Association (YMCA), and purchasing new equipment for Christ Community Hospital in 1964. From left to right are James M. Stevenson, Jerry Lewis, Francis C. Dugan, Herman C. Nebel, and Dr. Karl H. Meyer. (Courtesy of the Oak Lawn Public Library.)

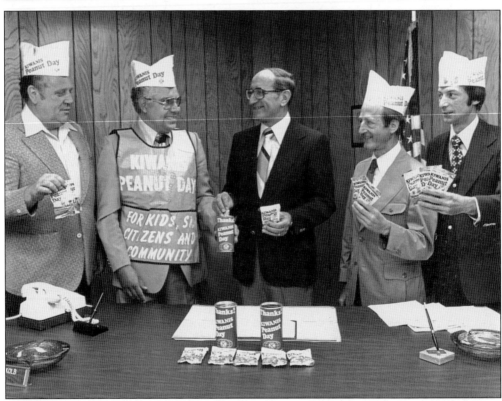

Since 1951, Kiwanis International has raised millions of dollars for local charities through its Peanut Day fundraisers. In September 1977, the Oak Lawn Kiwanis Club stopped by the village hall to promote the upcoming event. From left to right are Morrie Glens, John Speedwell, Mayor Ernie Kolb, Joe Fonte, and Wayne Baxtrom. (Photograph by Harry K. Thiem; courtesy of the Oak Lawn Public Library.)

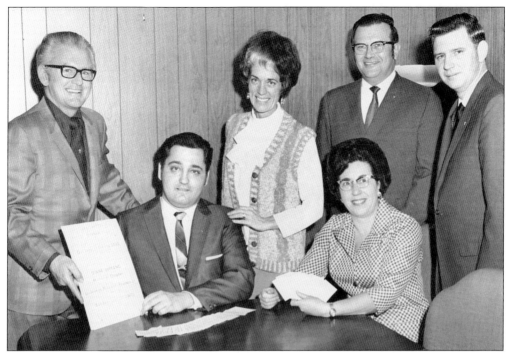

Representatives of the Oak Lawn Knights of Columbus, Our Lady of Fatima Council, sell tickets for a spaghetti dinner in this 1970 photograph. From left to right are (sitting) Lou Rega and Mrs. John Hughes; (standing) Matt Lamb, Mrs. Robert E. Morse, Dick Jousa, and Kenny Csuk. (Photograph by Harry K. Thiem; courtesy of the Oak Lawn Public Library.)

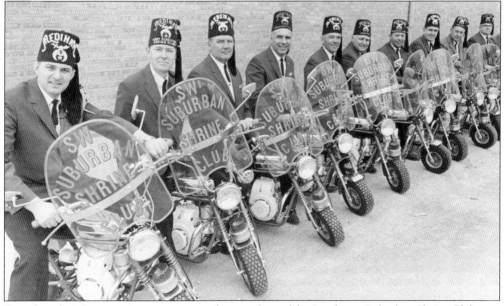

Seated on their famous miniature motorcycles, members of the Southwest Suburban Shrine Club pose in this 1969 photograph. From left to right are Wolfgang Rienke, Dr. Paul B. Stoxen, Richard Case, John Allyn, Phil Elliott, Bob Telander, Irv Armbruster, Wendell Spencer, Milfred Bettenhausen, Bill Lilly, and (out of the frame) Bill Peak. (Courtesy of the Oak Lawn Public Library.)

The Oak Lawn Elks Lodge was founded in 1962, just as fraternal organizations across the United States were seeing a rise in popularity. Fundraisers, golf outings, basketball competitions, and award ceremonies, such as this one held in 1980, are among its many contributions to the community. (Photograph by Don Weinzierl; courtesy of the Oak Lawn Public Library.)

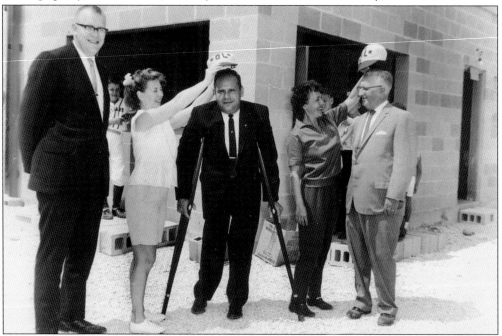

Formed in 1953, the Southwest Little and Pony League began with only four teams and equipment donated by the Chicago White Sox. Later renamed Oak Lawn Baseball for Boys, the organization grew to nearly 900 members by the early 1960s and built new facilities near Ninety-eighth Street and Central Avenue in 1962. Mayor Fred M. Dumke (center) attended the dedication ceremony. (Photograph by Don Weinzierl; courtesy of the Oak Lawn Public Library.)

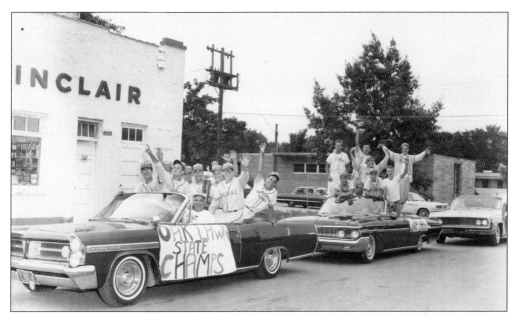

Riding in open convertibles near Ninety-fifth Street and Cook Avenue, members of the Oak Lawn Baseball for Boys celebrate their 1963 state championship. The team went on to compete in the national championship games held in New Mexico and came away with a fifth-place finish. (Photograph by Don Weinzierl; courtesy of the Oak Lawn Public Library.)

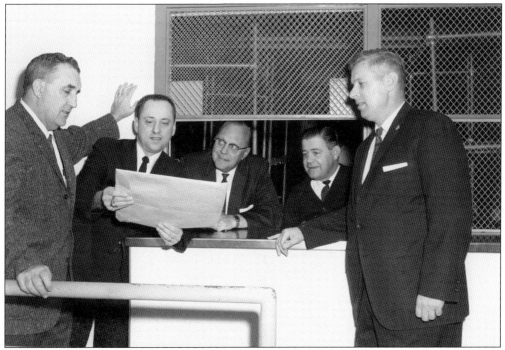

Created in 1944, the Oak Lawn Park District acquired its first piece of land the following year, when Lake Shore Park was purchased for just $25. Over the next several decades, the district board, pictured in 1965, rapidly expanded the system to include parks such as Brandt, Phillips, and Harker. (Photograph by Don Weinzierl; courtesy of the Oak Lawn Public Library.)

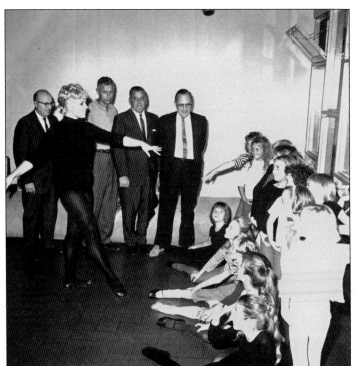

Watching intently, young dancers look to their teacher for guidance in this 1965 Oak Lawn Park District class. As the village's population continued to grow in the 1960s, the park district offered a number of different programs, including wrestling, basketball, and tennis. (Photograph by Don Weinzierl; courtesy of the Oak Lawn Public Library.)

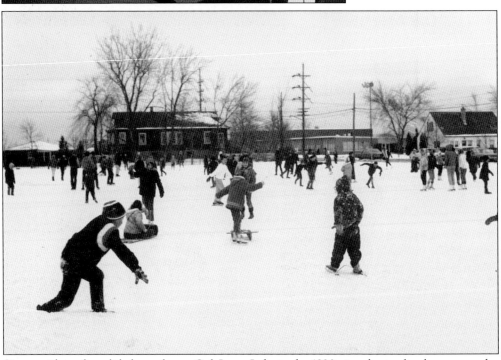

Since residents first glided on a frozen Oak Lawn Lake in the 1890s, ice-skating has been a popular pastime in the village. Taken in 1966, this photograph shows a number of children enjoying themselves at one of the Oak Lawn Park District's skating rinks. (Photograph by Don Weinzierl; courtesy of the Oak Lawn Public Library.)

Appearing at an Oak Lawn Park District fashion show, these local models display some of the hottest styles of 1974. On the left is Anita Aardema, and on the right are, in an unknown order, Michelle Weiss, Kathy Geary, Cindy Weiss, Laura Pudik, Linda Pudik, and Laura Schneider. (Photograph by Harry K. Thiem; courtesy of the Oak Lawn Public Library.)

Established during the Great Depression, the Oak Lawn Public Library opened in 1936 with the assistance of a Works Progress Administration grant. The first library was housed in an old barn near Ninety-fifth Street and Cook Avenue, with some of its furniture coming from the 1933 World's Fair. Initially, one part-time librarian was hired to manage a collection that included several hundred books. (Courtesy of the Oak Lawn Public Library.)

In 1943, Jenny Simons took over for Edith Exter as Oak Lawn Public Library's head librarian. Earning just $50 per month, she managed a collection that had grown to nearly 1,900 books and kept the library open to the public 17 hours a week. (Courtesy of the Oak Lawn Public Library.)

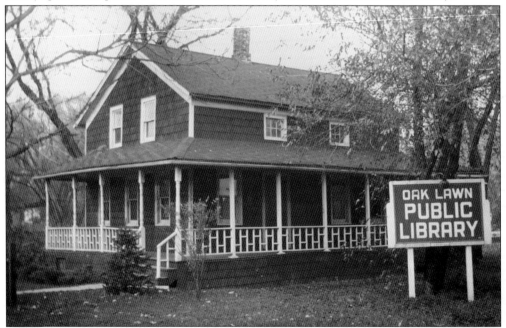

With a growing collection and an increased demand for space, the Oak Lawn Public Library moved into the former Chamberlain home in 1946. Built around 1845, the home originally stood near Minnick Avenue but was moved closer to Cook Avenue after the Chamberlain family left for California in 1890. (Courtesy of the Oak Lawn Public Library.)

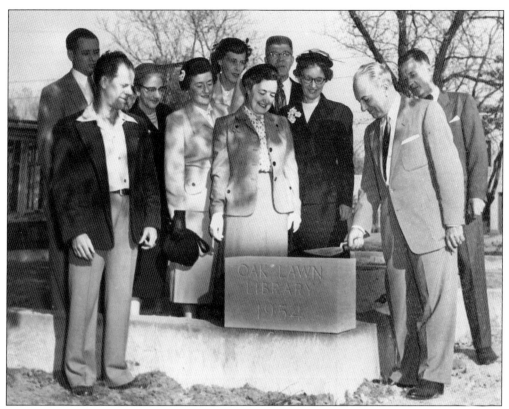

In October 1954, the Oak Lawn Public Library held a cornerstone ceremony as construction started on a new building. Librarian Dee Kopf, standing in the center behind the stone, and Mayor Harvey Wick, holding the small trowel, were among those in attendance. The new library was completed the following year at a cost of $30,000. (Courtesy of the Oak Lawn Public Library.)

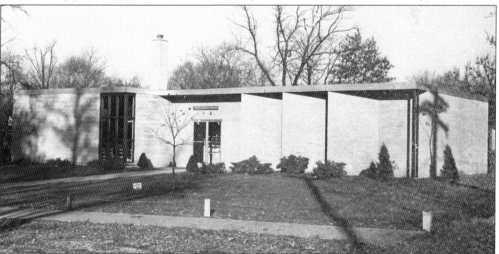

Trying to keep pace with village's growing population, the Oak Lawn Public Library continued to expand services during the 1950s by boosting its open hours, lending audio records, and purchasing nearly 400 new books a month. By the end of the decade, the library housed nearly 13,000 books and records. (Courtesy of the Oak Lawn Public Library.)

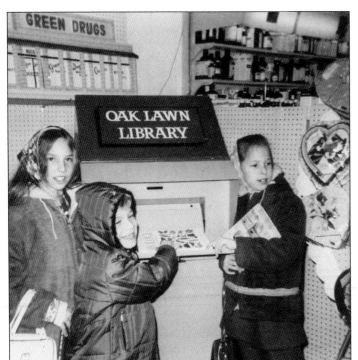

Beginning in the early 1970s, the Oak Lawn Public Library installed book drops at a number of different locations across the village. One of these, located at Green Drugs near 111th Street and Crawford Avenue, is shown in this 1972 photograph. Kevin Morris is standing near the center, and his sisters Kim and Lisa are on either side. (Courtesy of the Oak Lawn Public Library.)

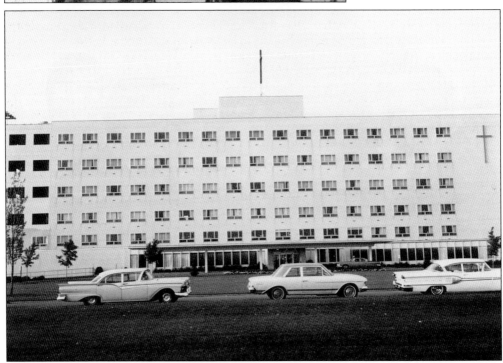

Christ Community Hospital, now known as Advocate Christ Medical Center, opened in 1961 as the first large-scale medical institution in Oak Lawn. Pictured in 1964, the hospital was already undergoing an expansion to help accommodate the growing number of patients. (Photograph by Don Weinzierl; courtesy of the Oak Lawn Public Library.)

Five

BUSINESS AND COMMERCE

Through the course of its history, hundreds of different businesses have lined the village's roadways, providing a livelihood for residents and helping to build the local economy. In the years prior to incorporation, Brandt's Tavern, Hoffman's Blacksmith Shop, Crandall's Grocery, and Schultz's Store were among the first businesses to enter Oak Lawn. Serving the needs of a rural population, they sold grain, tools, and other farming implements. As the village slowly grew, Ninety-fifth Street became the primary thoroughfare, attracting new shops, banks, and restaurants. By the 1920s, the explosion in popularity of the automobile sent dramatic changes throughout the nation. In Oak Lawn, service and fuel stations, including Hablash's near Ninety-fifth Street and Fifty-fifth Avenue, replaced the blacksmith and wagon shops that for so long had been part of local landscape. In addition, larger department stores and supermarkets, such as Behrend's Hardware and the Atlantic & Pacific Tea Company (A&P), introduced residents to a new and more convenient way to shop. During the difficult years of the Great Depression, many Oak Lawn businesses struggled to stay open, as jobs became scarce and individuals had far less available income. It was not until the early 1940s, and America's involvement in World War II, that the Depression finally lifted. After the war's conclusion in 1945, the national economy, and that of Oak Lawn's, saw tremendous growth. When the village's population boomed, numerous businesses of every kind arrived to meet the demand. In particular, restaurants like Jack Kilty's, Banana's Steak House, the Branding Iron, and Edmund's became popular destinations. Over the last few decades, changing tastes and redevelopment have resulted in the closing of older businesses. Though many of these locations are now just a memory, their impact on the local culture is still felt today.

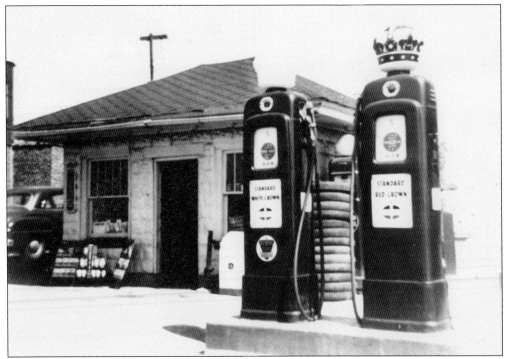

The automobile industry was still in its infancy when this Standard Gasoline station was built in 1916. Located near Ninety-fifth Street and Fifty-fifth Avenue, the station went through several owners before it was purchased by Edward Spitzer and renamed Spitzer's Service Station in 1933. (Courtesy of the Oak Lawn Public Library.)

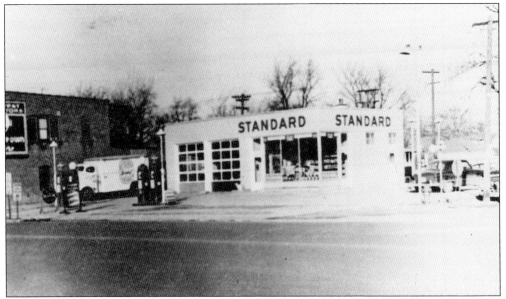

As the automobile grew in popularity in Oak Lawn and across the United States, so did the demand for fuel and maintenance services. Taken during the 1940s, this photograph shows a remodeled Spitzer's Service Station that added more fuel pumps, larger retail space, and a two-bay garage. (Courtesy of the Oak Lawn Public Library.)

When Ninety-fifth Street was significantly widened in the 1960s, Spitzer's Service Station once again remodeled and moved farther back from the road. The station, pictured around 1970, remains largely the same today and is one of the oldest active businesses in Oak Lawn. (Courtesy of the Oak Lawn Public Library.)

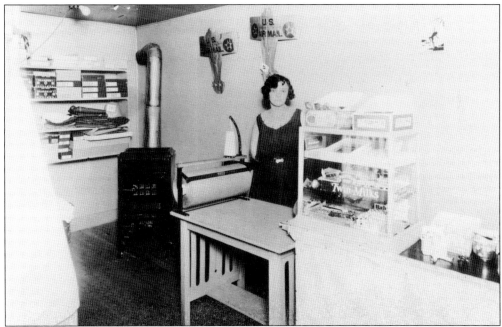

Irene Talsma, the owner and operator of Irene's Shoppe on Ninety-fifth Street, poses behind the counter in 1931. The store sold a number of products, including toys, candy, and clothes, and was typical of the many small businesses that lined Ninety-fifth Street by the early 1930s. (Courtesy of the Oak Lawn Public Library.)

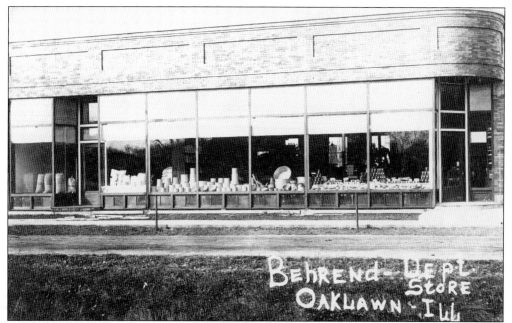

After his first business was destroyed by fire in January 1912, August Behrend worked quickly to open a new store at Ninety-fifth Street and Raymond Avenue. Selling a mix of items such as hats, paint, glass, jewelry, sporting goods, and farm supplies, Behrend's Hardware became an Oak Lawn staple for the next six decades. (Courtesy of the Oak Lawn Public Library.)

In the early 1970s, the Oak Lawn Public Library was preparing for several expansions that would more than double its size. To make room for the new additions, several businesses, including Behrend's Hardware (left) and Dewey's Tavern (right), were purchased and then torn down. (Photograph by Don Weinzierl; courtesy of the Oak Lawn Public Library.)

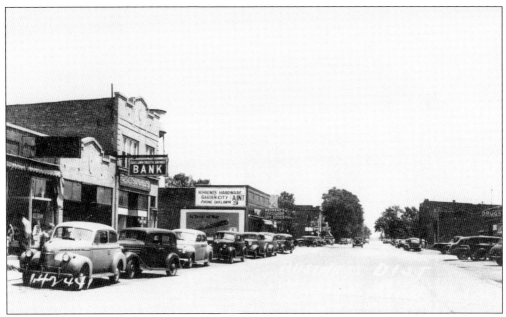

Taken two days after the German surrender in World War II, this 1945 image of Ninety-fifth Street looking east offers one of the last glimpses of a rural Oak Lawn. Several businesses, such as the Oak Lawn Trust & Savings Bank and Behrend's Hardware, are visible on the left, while the sign for Ratajik's Drugstore can be seen on the far right. (Courtesy of the Oak Lawn Public Library.)

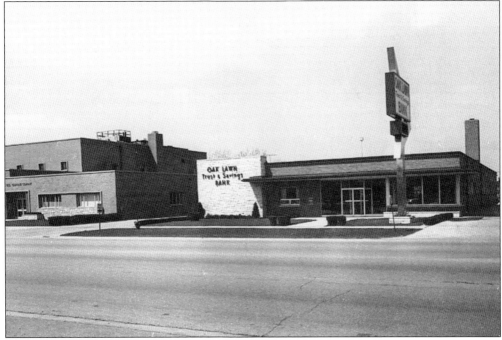

Opened in 1925, the Oak Lawn Trust & Savings Bank was one of the village's earliest financial institutions and played a prominent role during the building boom that began in the late 1940s. Around 1960, the bank moved to a new location near Ninety-fifth Street and Forty-ninth Avenue. (Photograph by Walter Neal; courtesy of the Oak Lawn Public Library.)

Earl Ayers, the owner of Ayer's Ice Cream Parlor, poses next to his shop at Ninety-fifth Street and Cook Avenue. The parlor, a popular location in Oak Lawn during the 1920s, is located on the right, while the Hilgendorf House is visible on the left. (Donated to the library by Edna Leppin.)

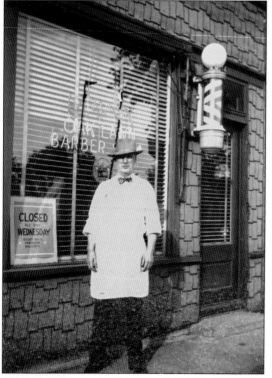

Barber Rueben Larson stands proudly in front of his shop on Ninety-fifth Street in 1951. As one of only three barbers in Oak Lawn at the time, Larson served a population that had grown to over 9,000 residents. (Donated to the library by Katherine Trimble.)

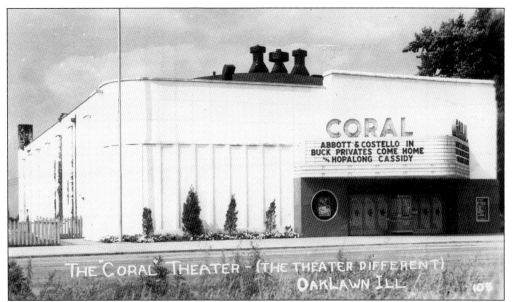

Built in 1942, the Coral Theater opened as the first indoor movie venue in Oak Lawn. Tickets cost 11¢ for children and 22¢ for adults, with the films changing upwards of three times a week. When this picture was taken in 1947, Abbott and Costello and Hopalong Cassidy were the featured movies. (Courtesy of the Oak Lawn Public Library.)

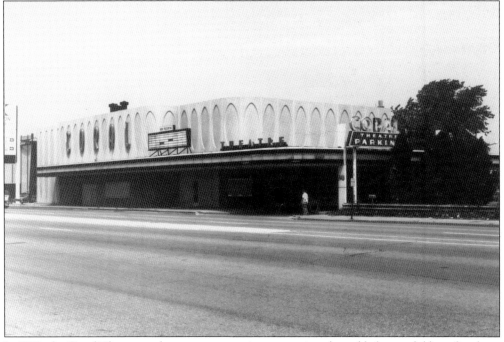

In 1963, the Coral Theater underwent an extensive renovation that added a new lobby, a fireplace, and murals painted by Martin Ziegner. These improvements helped the theater keep pace with a changing industry, but by the 1980s multiplexes and cable television were driving out older cinemas. Due to mounting debt, the Coral Theater was torn down in 1984 and replaced by a shopping plaza the following year. (Courtesy of the Oak Lawn Public Library.)

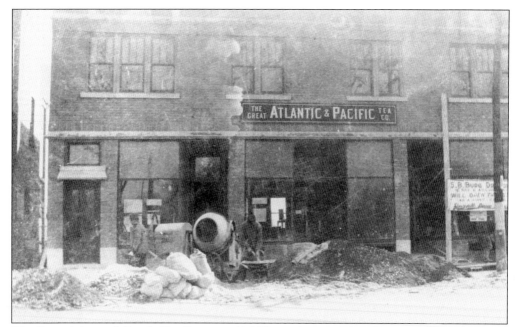

The Great Atlantic & Pacific Tea Company (A&P) was America's first discount grocery chain and operated stores in thousands of communities across the country. The Oak Lawn branch, located near Ninety-fifth Street and Cook Avenue, is pictured around 1925 with some construction work in the foreground. (Courtesy of the Oak Lawn Public Library.)

Decades after the A&P left this location, businesses such as Veli's Kofy Kup, Bob Kane Insurance, and Vidfile Technology filled the old storefront. At the time of this 1991 photograph, Oak Lawn was in the midst of a redevelopment that would continue into the new millennium. Both of these buildings were torn down in 2004. (Photograph by Thomas Grega; courtesy of the Oak Lawn Public Library.)

Standing at the microphone, Jack Thompson addresses the crowd at the grand opening of his Oldsmobile dealership in 1953. Located near Ninety-fifth Street and Pulaski Avenue, a customer could purchase a new four-door sedan for as little as $3,000 when the dealership opened. (Donated to the library by Jack Thompson.)

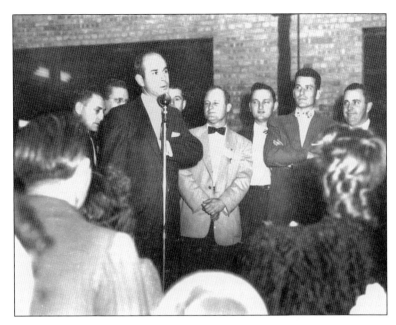

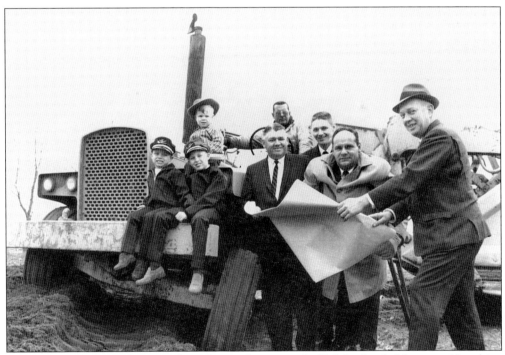

Attended by Mayor Fred M. Dumke and several trustees, the Holiday Inn held a ground-breaking ceremony in April 1967. For the next four decades, the hotel hosted numerous meetings, political rallies, and parties, acting as an important gathering spot until it was torn down in 2005. (Photograph by Don Weinzierl; courtesy of the Oak Lawn Public Library.)

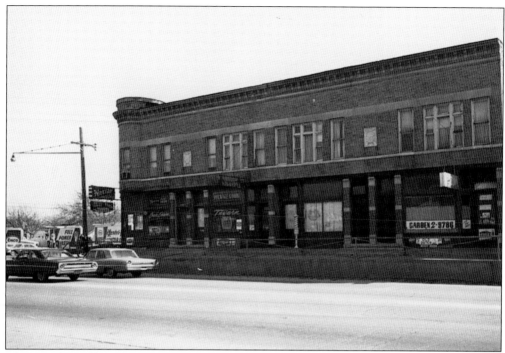

The Brandt Building, located near Ninety-fifth Street and Tulley Avenue, was nearly 70 years old at the time of this 1965 photograph. Although much of the original structure was still intact, prominent features such as the cone-shaped tower and the Brandt marker had been removed. (Photograph by Walter Neal; courtesy of the Oak Lawn Public Library.)

By 1991, five years before it was demolished, the Brandt Building had undergone such extensive renovations that it would have been nearly unrecognizable to its builders. Many of the changes occurred around 1966 when, in preparation for the widening of Ninety-fifth Street, the face of the structure was removed along with the elevated sidewalk that ran in front. (Photograph by Thomas Grega; courtesy of the Oak Lawn Public Library.)

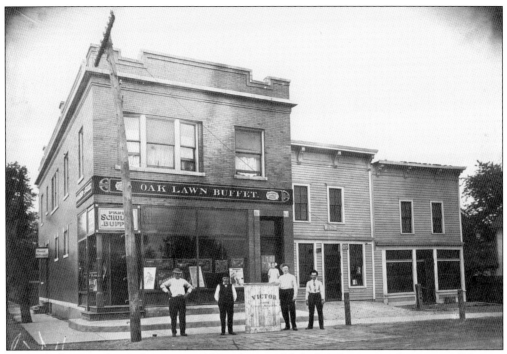

Fred Schultz moved to Oak Lawn in 1876 and opened Schultz's Store near the corner of Ninety-fifth Street and Cook Avenue in 1912. At various times, the building also served as a post office and telegraph office. From left to right are Walter Schultz, Fred Schultz, Edna Schultz, and two unidentified people. (Donated to the library by Edna Leppin.)

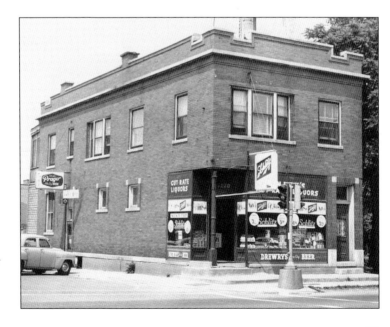

Although the former Schultz's Store had changed little by the 1950s, the world around it had been altered dramatically. Automobiles and stoplights now lined a bustling Ninety-fifth Street, telephones replaced telegraphs, and many of the surrounding buildings had been renovated or torn down. (Courtesy of the Oak Lawn Public Library.)

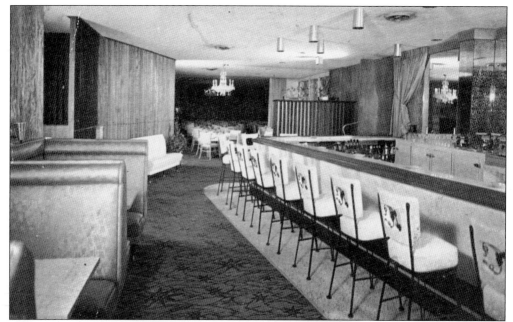

Remembered for its themed party rooms, dancing, weekly fashion shows, and political gatherings, Jack Kilty's on Ninety-fifth Street was one of the more popular restaurants in Oak Lawn during the 1950s and 1960s. The bar, known as the Cord and Tassel Lounge, is pictured around 1960. (Courtesy of the Oak Lawn Public Library.)

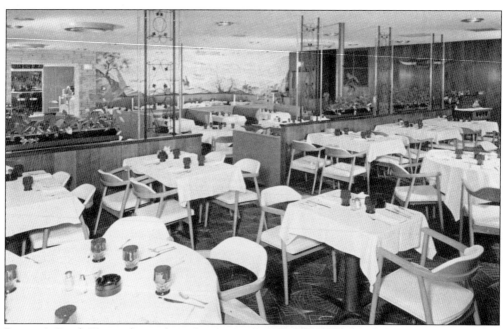

Banana's Steak House, located on Cicero Avenue, featured a tropical theme, piano bar, and nightly entertainment. The dining room, pictured here in 1960, served a number of different specialties, including steaks, chicken, seafood, and barbecued ribs. (Courtesy of the Oak Lawn Public Library.)

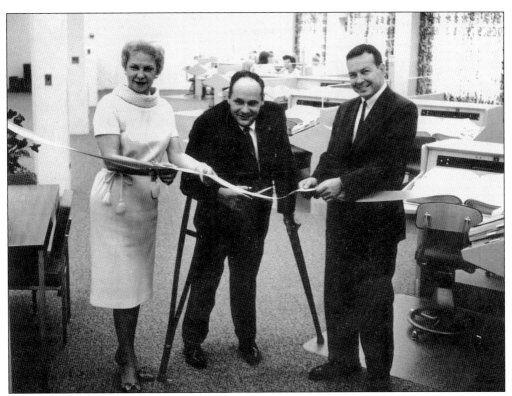

Illinois Bell, part of the American Telephone & Telegraph Company (AT&T), constructed new Oak Lawn offices in 1966. Mayor Fred M. Dumke, standing in the center, was on hand for the ribbon-cutting ceremony along with two Bell employees. (Photograph by Don Weinzierl; courtesy of the Oak Lawn Public Library.)

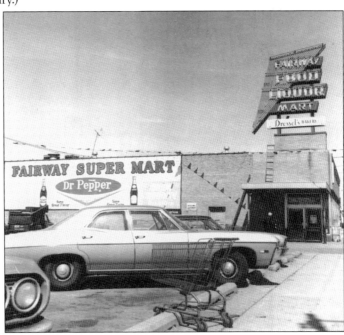

Opened in 1965, the Fairway Super Mart was located near the intersection of Ninety-fifth Street and Southwest Highway in a building formerly occupied by the National Food Store. On April 21, 1967, many businesses, including the Fairway, were destroyed in the tornado. (Photograph by Joe Martin; donated to the library by Joe Martin.)

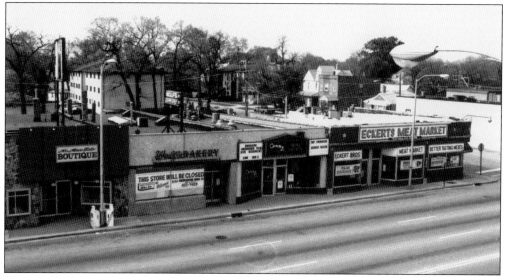

Since 1989, large sections of Ninety-fifth Street have undergone extensive redevelopment. Many of the older businesses, such as these located between Cook Avenue and Fifty-second Avenue, were torn down and replaced by newer retail structures. From left to right are the Mrs. Marco Polo Boutique, Wolf's Bakery, Century 21, and Eckert's Meat Market. (Photograph by William Goodfellow; donated to the library by William Goodfellow.)

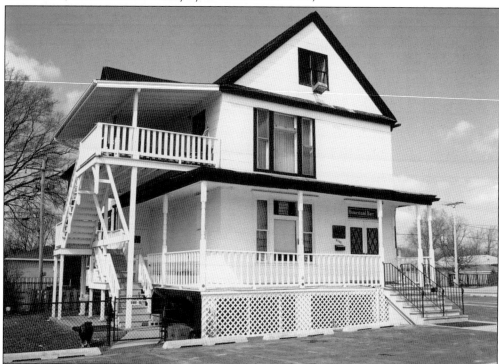

Located near Southwest Highway and Central Avenue, the Homestead Barr opened in 1951 with Ed and Dorothy Adomaitis as owners. The converted farmhouse, originally built by the Simpson family, is among the oldest structures in Oak Lawn, having been completed around 1858. (Photograph by William H. Cramp; courtesy of the Oak Lawn Public Library.)

Six

GOVERNMENT AND POLITICS

Since the first election held in March 1909, Oak Lawn politics have been a source of controversy, pride, and capable leaders. During its earliest years, figures such as James Montgomery, William Gaddis, and Frank Harnew assisted in the village's transition from a small, rural community to that of a developing suburb. The introduction of gas and electric service, concrete sidewalks, paved streets, and a reliable water system were made possible by the work of both elected officials and private citizens acting through the local government. In later years, Albert Brandt, Tunis Collings, and Harvey Wick were among the many individuals who led Oak Lawn through the Great Depression, World War II, and into the boom years that began in the late 1940s and early 1950s. As one of the villages most recognized and longest tenured politicians, Fred M. Dumke served as a trustee and clerk until he was elected mayor in 1961. Known as a strong-willed individual, Dumke worked to ensure that enough schools, utilities, and homes were available for the thousands of new residents entering the village each year. His toughest challenge came in April 1967 when a tornado struck Oak Lawn with devastating results. Dumke, along with many other public officials, helped organize relief efforts and brought in temporary trailers to house those who had lost their homes. Later in his tenure, several controversial events, including the hotly contested 1973 election with Thomas Powell and charges of mail fraud from which he was acquitted, made headlines. Following Dumke's decision to retire from politics, Ernie Kolb was elected mayor in 1977 and served until his death in 2003. Kolb presided over one of the most dramatic—and contentious—eras in Oak Lawn's history, as the village's redevelopment led to many improvements but also the loss of historic structures and long-standing businesses. Through the many elections, accomplishments, and disputes, politics and government—much as they have over the last century—remain an important aspect of Oak Lawn.

At the time of this 1959 photograph, few would remember that the Oak Lawn Shoe Store, located on Ninety-fifth Street, was the site of the village's founding 50 years earlier. On February 4, 1909, residents gathered at the store, then known as Larsen's Hall, to vote on incorporation. By a count of 59 in favor with only 4 opposed, the village of Oak Lawn was officially born. (Courtesy of the Oak Lawn Public Library.)

James Montgomery arrived in Oak Lawn in 1899 and quickly became active in the community. In 1909, he helped organize the Oak Lawn Athletic Association and was elected the village's first mayor that same year. Montgomery served in office until 1912, helping to guide Oak Lawn during its earliest years. (Courtesy of the Oak Lawn Public Library.)

Remembered as one of Oak Lawn's busiest politicians, William B. Gaddis served as clerk, trustee, and mayor over a period of eight years. Although he and his wife, Lucille, left the village for more than a decade, they returned in 1934, and William was once again elected clerk in 1949. (Courtesy of the Oak Lawn Public Library.)

Housed in a simple block structure, the village hall and police station were located near Ninety-fifth Street and Cook Avenue in 1948. The right side of the building held government offices after it was constructed in 1911, while the left side, which acted as police headquarters, was added at a later date. (Courtesy of the Oak Lawn Public Library.)

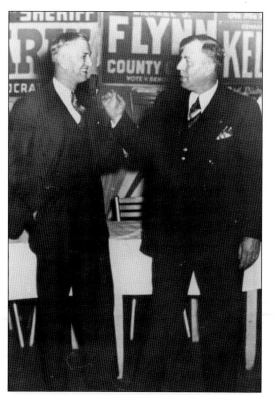

Otto Brandt (left) and Albert Brandt pose at a political rally around 1940. Beginning in the 1920s, Albert became a leading politician in Oak Lawn and served as mayor from 1935 to 1944. Otto was elected as a trustee in 1928 and successfully ran the family tavern for many years. (Courtesy of the Oak Lawn Public Library.)

Elected as mayor in 1953, Oak Lawn's population was just over 13,000 when Harvey Wick took office. During his tenure, the number of residents more than doubled, creating an immense need for homes, schools, parks, and services. (Donated to the library by Fred M. Dumke.)

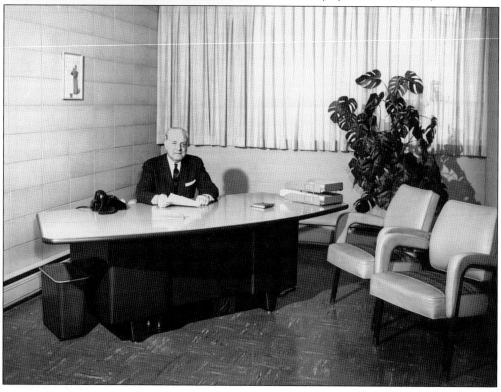

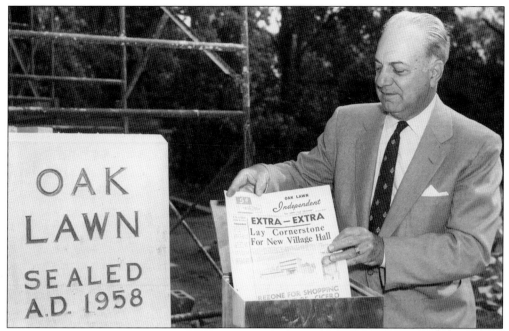

With an exploding population and increasing demand for government assistance, construction on a new village hall began in 1958. As part of the cornerstone ceremony, Mayor Harvey Wick inserted several items, including a copy of the *Oak Lawn Independent*, into a time capsule. (Courtesy of the Oak Lawn Public Library.)

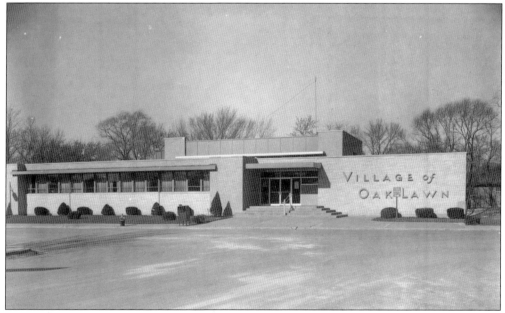

Dedicated in 1959, the Oak Lawn Village Hall was located near Ninety-fifth Street and Cook Avenue. Originally designed to have two stories but completed with only one, the building served residents for over 30 years before it was demolished in the 1990s. The village green now covers the land where the structure once stood. (Photograph by Don Weinzierl; courtesy of the Oak Lawn Public Library.)

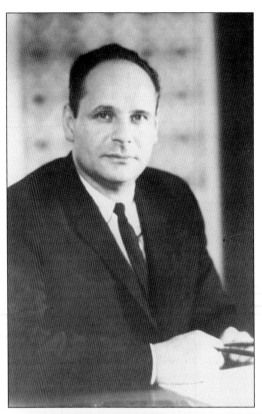

Serving Oak Lawn for nearly a quarter of a century, Fred M. Dumke began his local political career in 1953 when he was elected trustee. Quickly making a name for himself, Dumke successfully ran for mayor in 1961 and served in that capacity until leaving office in 1977. (Photograph by Don Weinzierl; courtesy of the Oak Lawn Public Library.)

Mary Brandt, the wife of former mayor Albert Brandt, attended a park dedication honoring her late husband in 1962. Mary was a well-known public figure, serving as a Democratic committeewoman and member of the Nonpartisan Party. Holding flowers, she is standing second from the left, with Mayor Fred M. Dumke standing on the far right in front. (Photograph by Don Weinzierl; courtesy of the Oak Lawn Public Library.)

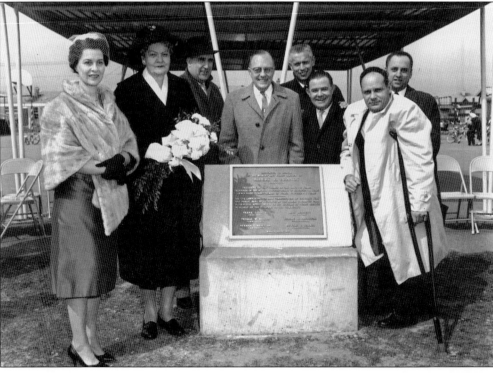

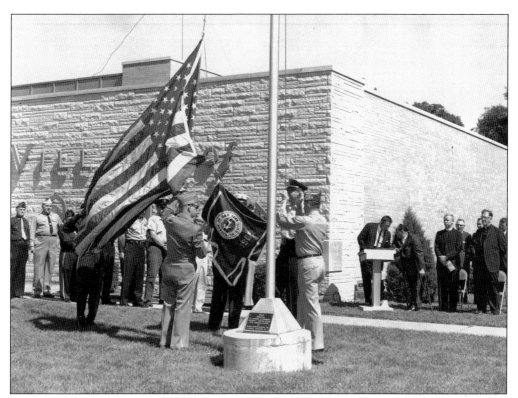

A new Oak Lawn flag was unveiled in July 1964, and a special ceremony took place in front of the village hall to mark the occasion. The flag's final look was a composite of the best overall designs submitted by schoolchildren. (Photograph by Don Weinzierl; courtesy of the Oak Lawn Public Library.)

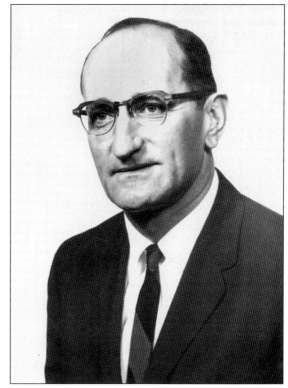

After serving in the Navy during World War II, Ernie Kolb moved to Oak Lawn in 1947 and entered politics a decade later when he was appointed to the village board of appeals. In 1964, Kolb won his first election when he successfully ran for the position of clerk and was elected mayor in 1977. (Courtesy of the Oak Lawn Public Library.)

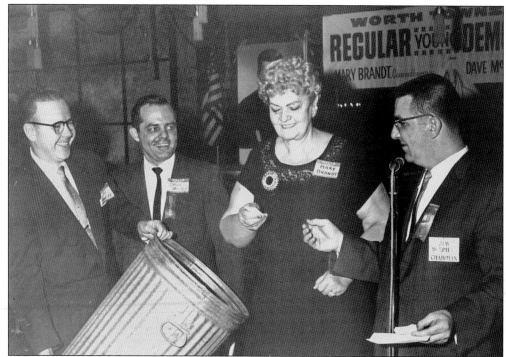

The Worth Township Regular Young Democrats sponsored a Mardi Gras celebration at Jack Kilty's Restaurant in February 1968. As part of the festivities, a drawing was held in which the winner received an all-expenses-paid weekend at the Wagon Wheel Lodge in Rockton, Illinois. From left to right are Sinclair Randall, David McCoy, Mary Brandt, and Jim Murphy. (Courtesy of the Oak Lawn Public Library.)

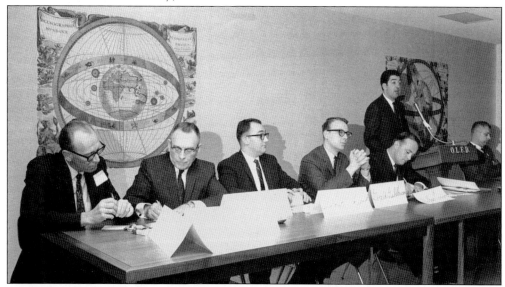

Active through much of the 1950s and 1960s, the Oak Lawn Nonpartisan Party ran candidates such as Leonard Cole and Harry "Bus" Yourell. In 1967, members of the party spoke to the Oak Lawn chapter of the League of Women Voters. (Photograph by Don Weinzierl; courtesy of the Oak Lawn Public Library.)

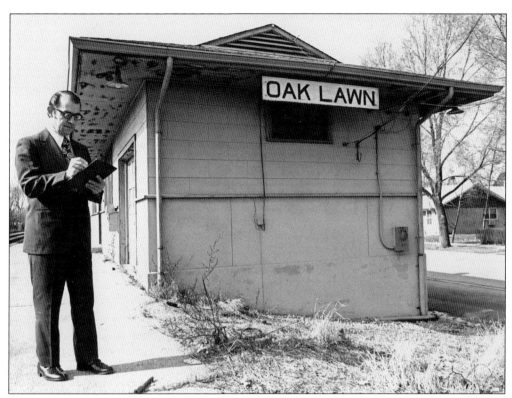

David Morris, a trustee candidate for the United Oak Lawn Party, awaits commuters at the Oak Lawn Train Depot in 1973. That year, residents witnessed one of the most hotly contested elections in village history. (Photograph by Gene Pahnke; courtesy of the Oak Lawn Public Library.)

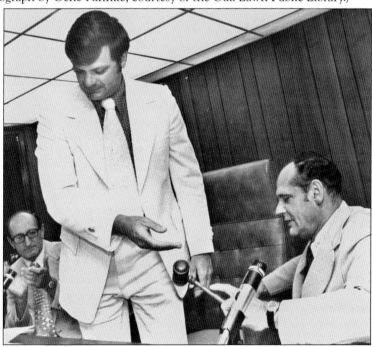

Handing back the gavel, Dr. Thomas Powell (left) relinquishes his authority as mayor to Fred M. Dumke (right) in August 1973. While Powell was initially declared the winner by a few votes, the results were contested in court, which ultimately reversed the decision and ruled in Dumke's favor. Ernie Kolb, then serving as clerk, is visible in the background. (Courtesy of the Oak Lawn Public Library.)

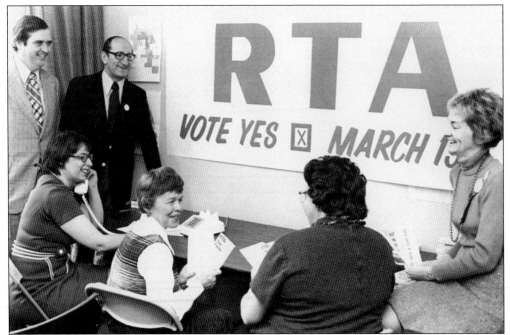

Campaigning for better transportation in the suburbs, the RTA (Regional Transportation Authority) Citizen's Committee opened a new Oak Lawn office in 1974. From left to right are J. Theodore Meyer, Clerk Ernie Kolb, Robin Kaufman, Dorothy Peterson, Carol Adams, and Mary Cannon. (Photograph by Harry K. Thiem; courtesy of the Oak Lawn Public Library.)

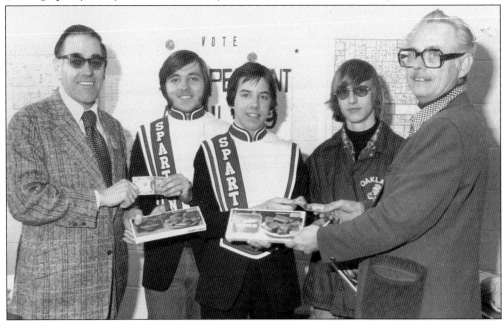

During the 1977 election, candidates Harold Bacon (far left) and Ed Meier (far right) stopped by the Oak Lawn Community High School to support the marching band's candy sale. Running for the positions of mayor and clerk, Bacon and Meier would ultimately lose the election to Ernie Kolb and Jayne Powers. (Photograph by Harry K. Thiem; courtesy of the Oak Lawn Public Library.)

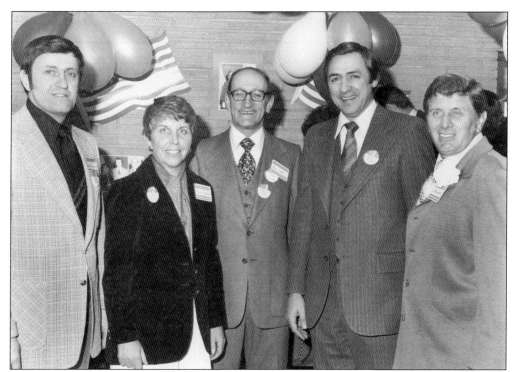

Members of the Oak Lawn Citizens Coalition Party pose during the 1977 election campaign. From left to right are trustee candidate Jay Bergamini, clerk candidate Jayne Powers, mayoral candidate Ernie Kolb, George Sinadinos, and campaign chairman Lou Mirabelli. (Photograph by Harry J. Thiem; courtesy of the Oak Lawn Public Library.)

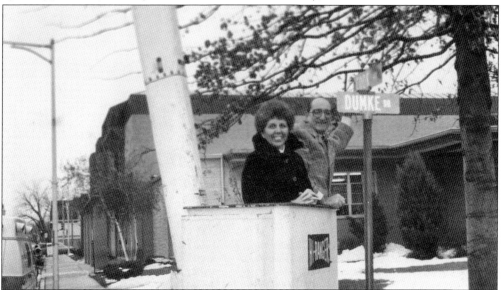

To honor his nearly 25 years of service in Oak Lawn, James Drive was renamed Dumke Drive in December 1977. Standing in a cherry picker parked just behind the library, Clerk Jayne Powers (left) and Mayor Ernie Kolb (right) pose next to the newly installed street sign. (Courtesy of the Oak Lawn Public Library.)

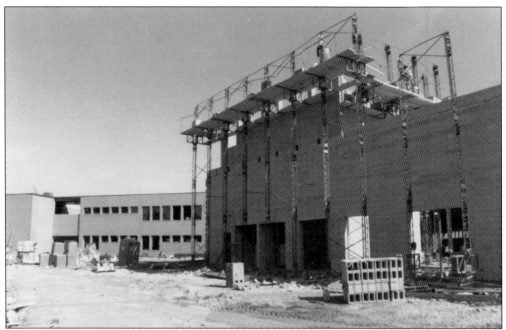

Planning for Oak Lawn's redevelopment took shape in 1988, and construction began on a new public-safety center located near Ninety-fifth Street and Raymond Avenue the following year. Dedicated in 1991, the center merged the police department, fire department, and government offices into one building. (Photograph by Barbara Wolfe; courtesy of the Oak Lawn Public Library.)

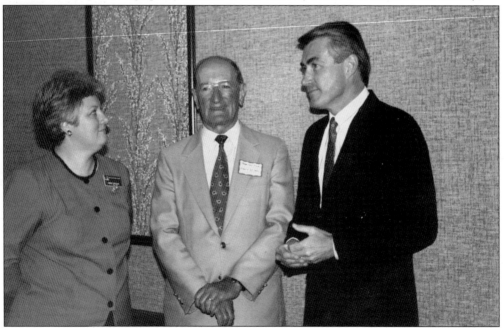

In August 1990, shortly before he was elected governor, Illinois secretary of state Jim Edgar visited the Oak Lawn Public Library. From left to right are library director Joy Kennedy, Mayor Ernie Kolb, and Secretary of State Jim Edgar. (Photograph by Gerald Anderson; courtesy of the Oak Lawn Public Library.)

Seven

TO SERVE AND PROTECT

Providing safety and protection for residents of Oak Lawn, the police and fire departments are among the village's earliest institutions. As the older of the two, the police department's history can be traced back to the hiring of Frank O'Brien as marshal in 1909. Brought on shortly after incorporation for a salary of $25 a year, he helped usher the era of professional law enforcement into Oak Lawn. As part of his duties, O'Brien enforced local laws, collected fines, and acted as jail keeper. When more people settled in the village during the 1920s and 1930s, the police department kept pace by hiring more men, forming a club to raise funds, and purchasing radio-equipped patrol cars. These improvements allowed officers to adjust to increasing traffic demands and halt crimes, which included bank robberies, shootings, and sporadic mob violence. Just as the creation of a police force better protected residents from criminal acts, the organization of a volunteer fire department in 1923 vastly improved the village's ability to combat blazes. Previously, assistance from neighbors, who gathered water in buckets and wagons, was the only hope of extinguishing a fire; however, with upgraded equipment, better training, and more firemen, the volunteers quickly made an impact. Growing and developing alongside the community, the fire department became one of the cornerstones of the village and, in 1961, transitioned to full-time status. With the annexations of Grandview Park and Columbus Manor, along with the rescue efforts required after the 1967 tornado, the 1960s proved to be a challenging time for both Oak Lawn Police and Fire Departments. As the village matured, the two departments adapted to the changing needs of its residents. Today, the men and women who serve Oak Lawn uphold the standards set forth by their predecessors, safeguarding the lives and property of those in the community.

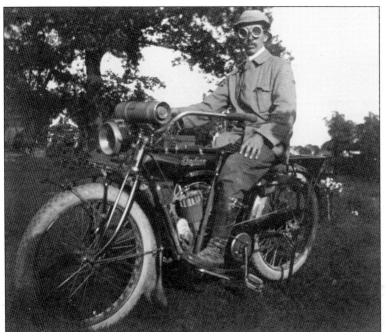

Pictured around 1915, special policeman Harry Fletcher sits atop his Indian motorcycle near Evergreen Farm at 103rd Street and Long Avenue. Fletcher, who earned $1 per arrest, was hired to enforce the 15-mile-per-hour speed limit imposed by the Oak Lawn Village Board. (Courtesy of the Oak Lawn Public Library.)

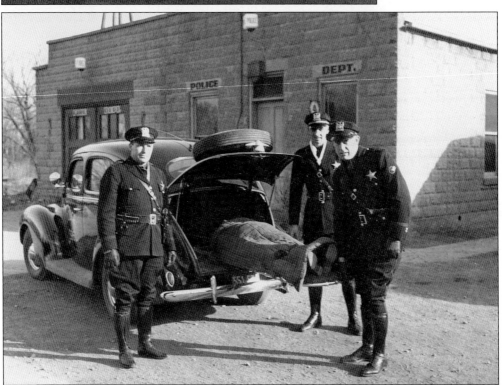

Officers of the Oak Lawn Police Department demonstrate a new squad car and ambulance in 1938. The block structure in the background was built as the village hall in 1911 but expanded to include both the fire and police departments. From left to right are Ed Hosman, Neal Mooi, and George Talsma. (Courtesy of the Oak Lawn Public Library.)

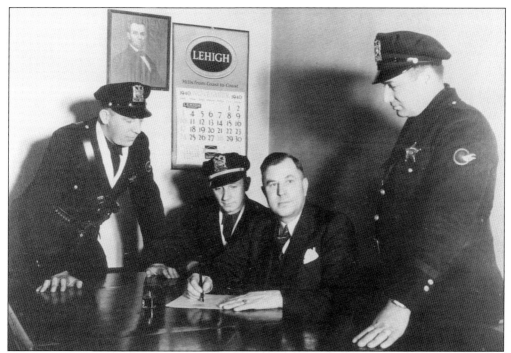

By 1940, the Oak Lawn Police Department had developed into a well-trained, well-equipped force that dealt with bank robberies, mob violence, drug trafficking, and youth gangs. From left to right are Capt. George Talsma, Chief Neil Mooi, Mayor Albert Brandt, and Sgt. Edward Hosman. (Donated to the library by Janette Talsma.)

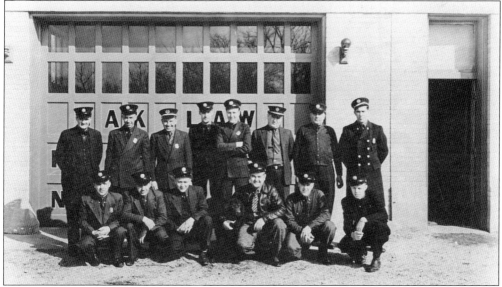

Organized in 1923, the Oak Lawn Fire Department operated on a volunteer basis at the time of this 1941 photograph. From left to right are (first row) Andrew Syverson, John Livingstone, Arthur Reno, Fred Behrend, Ed O'Malley, and Matthew Smiley; (second row) Huey Ralston, Edward Bulow, Paul Brueggeman, Louis Gunther, Edward Draper, Elmore Harker Sr., Walter Kaup, and Arthur Eichler Jr. (Courtesy of the Oak Lawn Public Library.)

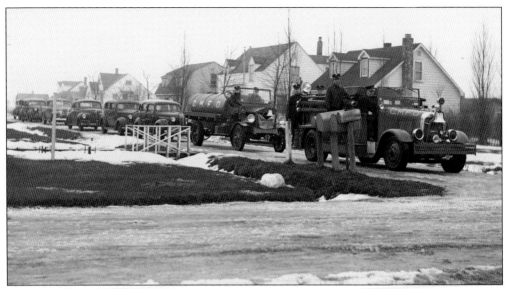

Prior to its annexation by Oak Lawn in 1965, the community of Columbus Manor operated its own fire protection district that also covered parts of Chicago Ridge, Bridgeview, and Worth. Taken in 1943, this photograph displays some of the equipment used by the Columbus Manor Fire Department. (Courtesy of the Oak Lawn Public Library.)

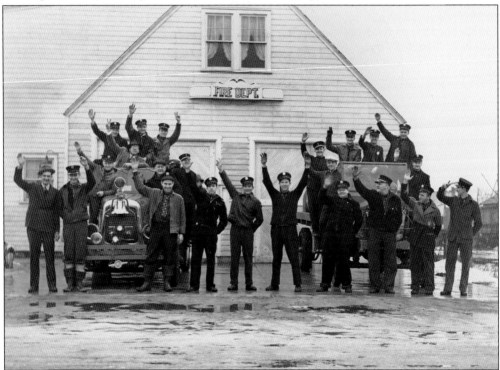

Standing outside of the firehouse, members of the Columbus Manor Fire Department pose with their equipment around 1945. In 1968, three years after the community was annexed, the volunteer firemen of Columbus Manor merged with those in Oak Lawn, creating a single department. (Courtesy of the Oak Lawn Public Library.)

Elmore Harker Sr. joined the Oak Lawn Volunteer Fire Department in 1931 and was appointed chief in March 1940. Under his watch, the department underwent a transformation that added more men, better equipment, and improved training. Harker, pictured next to a fire truck in 1946, served as chief until his passing in 1962. (Courtesy of the Oak Lawn Public Library.)

To keep pace with the growing community, the headquarters for both the Oak Lawn Police and Fire Departments, located near Ninety-fifth Street and Cook Avenue, underwent several expansions during the 1940s. Visible from left to right are the Preston residence, firehouse, village hall, and police station. (Donated to the library by Milt Andersen.)

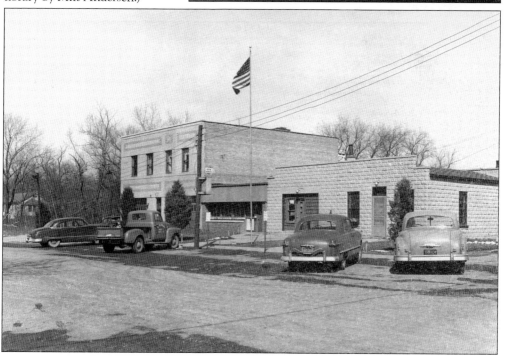

When a second firehouse became necessary in 1954, the Oak Lawn Fire Department started a fundraising drive to help offset the building's cost. Generous residents quickly met the goal of $18,000, with the remaining $9,000 balance donated in the form of labor during construction. (Courtesy of the Oak Lawn Public Library.)

Founded in 1939, the Grandview Park Fire Department protected an area that stretched from Eighty-seventh Street to Ninety-first Street and Central Avenue to Ridgeland Avenue. In this scene, captured around 1960, onlookers watch as Grandview Park firefighters work to extinguish a large blaze. (Courtesy of the Oak Lawn Public Library.)

With a look of gratitude and amazement, Chief Robert Pohlman (left) of the Grandview Park Fire Department accepts a $3,000 donation from the Women's Auxiliary in 1961. Four years after this photograph was taken, the department's men, equipment, and structures were merged with those of Oak Lawn. (Courtesy of the Oak Lawn Public Library.)

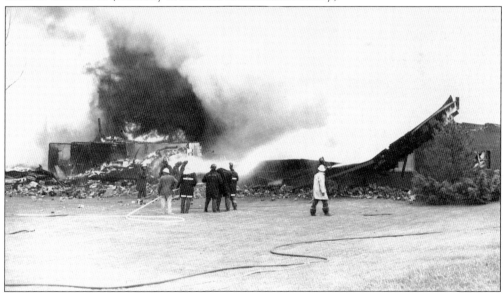

Although safety standards improved dramatically by the 1960s, fires still occurred from time to time. In July 1963, men from the Oak Lawn Fire Department battled a blaze at the Cramer Plant. By the time this photograph was taken, the fire had consumed most of the building. (Courtesy of the Oak Lawn Public Library.)

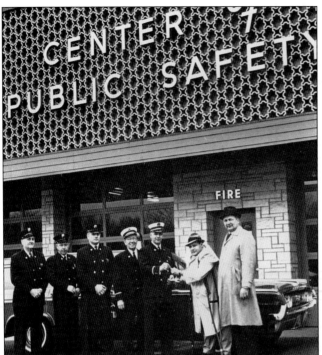

Dedicated in 1963, the Center of Public Safety combined the Oak Lawn Fire and Police Departments into one building, improving both communication and cooperation. From left to right are Ed Schmaelen, Jack Orr, Don Canning, assistant chief Paul Brueggeman, Kenneth Krause, Mayor Fred M. Dumke, and J.J. Salovaara. (Courtesy of the Oak Lawn Public Library.)

Fresh off their victory over the fire department, the Oak Lawn Police team is presented with a softball trophy in October 1964. From left to right are fireman Paul Brueggeman, chairman of the fire and police commission Joseph Valencik, and policeman Albert Miller. (Courtesy of the Oak Lawn Public Library.)

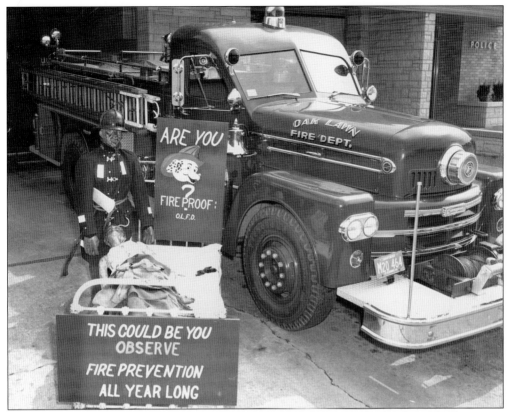

Positioned near the Center of Public Safety, this 1964 fire prevention display shows the dangerous consequences of smoking in bed. Although prevention has always been a goal of the Oak Lawn Fire Department, its importance grew as the village's population continued to expand. (Photograph by Don Weinzierl; courtesy of the Oak Lawn Public Library.)

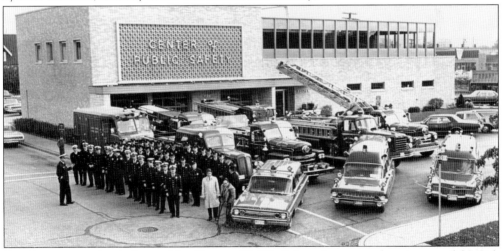

Standing at attention in front of the Center of Public Safety, the men and equipment of the Oak Lawn Fire Department undergo inspection in 1966. Though not all are present, the department employed 24 full-time and 44 part-time firemen that year. (Photograph by Gene Pahnke; courtesy of the Oak Lawn Public Library.)

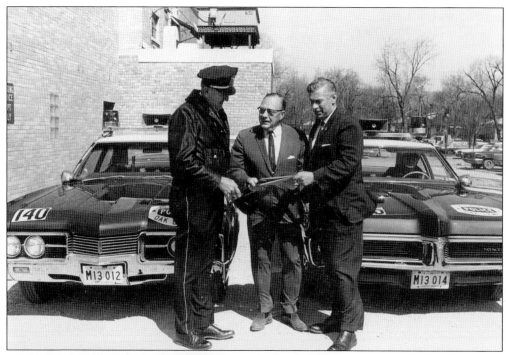

Equipped with the latest in law-enforcement technology, the Oak Lawn Police Department received new squad cars in 1967. Village trustee Leonard Cole (center) presented the vehicles in a small ceremony held at the Center of Public Safety. (Photograph by Don Weinzierl; courtesy of the Oak Lawn Public Library.)

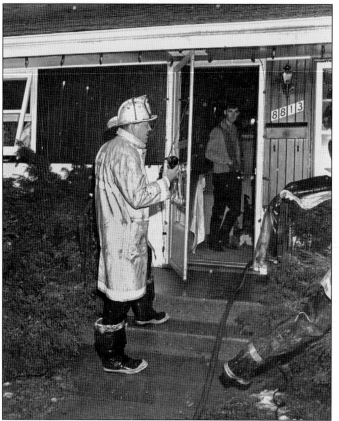

Allen Hulett was appointed chief of the Oak Lawn Fire Department in 1966, taking over for the recently retired John P. McCastland. The following year, he and the department were put to the test after a snowstorm blanketed the village in January and a tornado struck in April. Hulett retired from Oak Lawn in 1968, working his last fire in January of that year. (Courtesy of the Oak Lawn Public Library.)

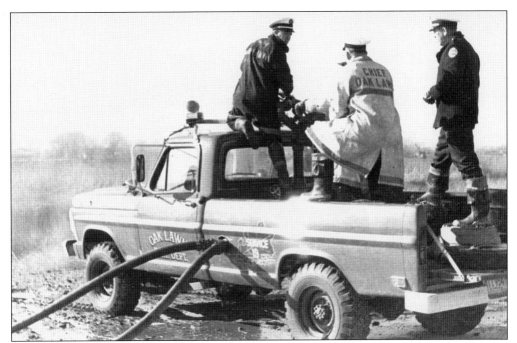

Bracing themselves against the immense pressure from the hoses, members of the Oak Lawn Fire Department test a recently acquired truck in March 1968. That year, Earl Vogelsanger replaced Allen Hulett as chief, who left Oak Lawn to serve in Elk Grove Village. (Photograph by Harry K. Thiem; courtesy of the Oak Lawn Public Library.)

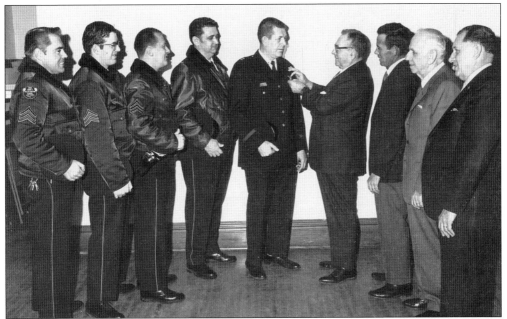

Officers of the Oak Lawn Police Department await their promotions in February 1971. From left to right are Donald Idzik, Harvey Hendrik, Robert Banas, Will Cole, George Kummer, Leonard J. Cole, Cornelius Ruiter, Frank A. Micklin, and Joseph Valencik. (Photograph by Harry K. Thiem; courtesy of the Oak Lawn Public Library.)

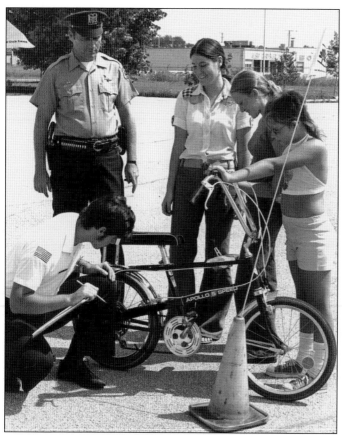

Carefully marking their checklist, officers Rosenberg (kneeling) and Mackey (standing) complete an inspection during the village's Bike Safety Rodeo in 1975. The girls in the photograph, from left to right, are Carol O'Donnell, Jan Dust, and Jodi Tewey. (Photograph by Harry K. Thiem; courtesy of the Oak Lawn Public Library.)

Amy Heidke (center) completes the Oak Lawn Fire Department's babysitting course in April 1977. Ron Murray (left) and Chief Al Harker (right) were on hand for the occasion and presented a newspaper that featured Amy when she was two years old. (Courtesy of the Oak Lawn Public Library.)

Eight
Tragedy and Triumph

The Friday morning of April 21, 1967, was crisp and clear, marking the arrival of spring. Early in the afternoon, as clouds covered the skies, a bulletin was issued for much of northern and central Illinois, warning of severe weather. Around 3:30 p.m., a series of tornados and fierce storms hit the Chicago area, blanketing Belvidere, Geneva, Elgin, and other communities. Just before 5:30 p.m., during the middle of the rush-hour commute, Oak Lawn was struck by one of the twisters. Cutting through the intersection of Ninety-fifth Street and Southwest Highway and striking other portions of the village, the tornado left demolished buildings, overturned cars, and mountains of debris in its wake. Oak Lawn Community High School, St. Gerald, Fairway Foods, the Sherwood Forrest Restaurant, and Shoot's Tavern were among the numerous schools, businesses, and homes that were damaged or completely destroyed by the high winds. In the hours and days following the disaster, rescue workers and volunteers poured into Oak Lawn to search for survivors, while Christ Community Hospital, Little Company of Mary, and other medical institutions treated the more than 400 injured. Local leaders, including Mayor Fred M. Dumke, helped organize relief efforts and worked to provide the nearly 600 homeless residents with temporary trailers. The immense cleanup effort, which took weeks to complete, saw tons of debris hauled out of the village or disposed of in controlled fires. Despite the scope of the devastation, many of the affected structures were repaired or rebuilt within 12 months of the disaster. On April 21, 1968, a ceremony held at the village hall marked the one-year anniversary of the event and honored the 33 men, women, and children who lost their lives.

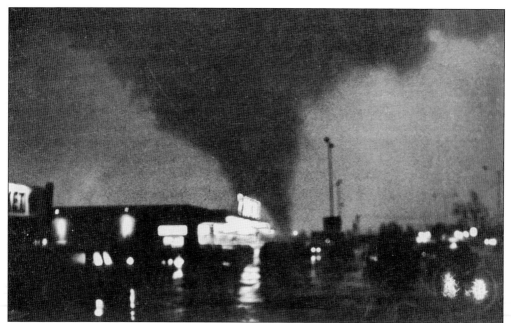

Touching down at approximately 5:29 p.m., the tornado quickly cut a path of destruction that stretched across Oak Lawn. This image, taken near Eighty-seventh Street and Harlem Avenue, was featured in the *Chicago American* and many other newspapers across the country. (Photograph by Elmer C. Johnson; donated to the library by Jeffery C. Johnson.)

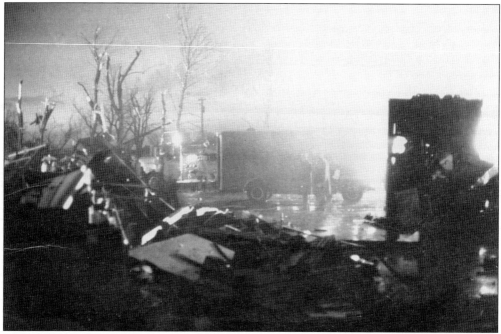

With darkness descending on the village, a combination of raging fires, few working lights, decimated buildings, and stripped trees created an eerie sight. Rescue workers and volunteers struggled throughout the night to clear away the huge amount debris in the search for survivors. (Photograph by David A. Johnston; donated to the library by Tom Johnston.)

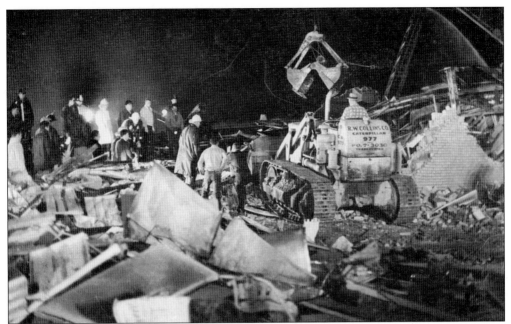

Located near Ninety-fifth Street and Southwest Highway, the Fairway Foods was filled with customers shopping for groceries when the tornado hit. Those inside the store ran for cover as the large front windows were smashed and the roof crashed down around them. After the storm had passed, only a pile of rubble stood in place of the once popular business. (Courtesy of the Oak Lawn Public Library.)

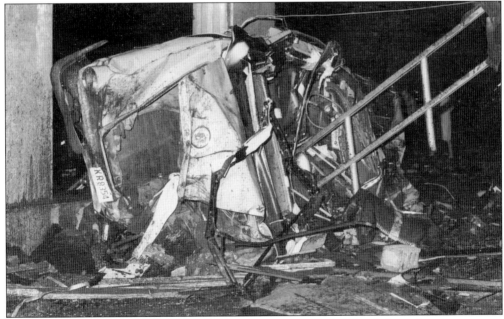

Spanning Southwest Highway near Oak Lawn Community High School, the pedestrian overpass became a scene of tragedy when drivers waiting underneath were caught in the storm. Many of the vehicles became twisted into nearly unrecognizable shapes by the fierce winds. (Photograph by David A. Johnston; donated to the library by Tom Johnston.)

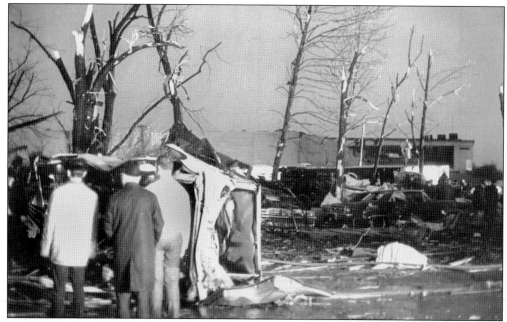

Overturned vehicles littered the intersection of Ninety-fifth Street and Southwest Highway in the tornado's wake. Striking during the middle of rush hour, the roads were filled with motorists returning home from work and running errands for the coming weekend. (Photograph by David A. Johnston; donated to the library by Tom Johnston.)

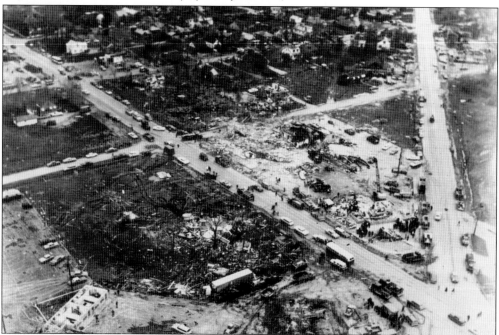

Sitting directly in the tornado's path, the intersection of Ninety-fifth Street and Southwest Highway witnessed some of the most intense damage and greatest number of fatalities. This aerial photograph, taken only a few days after the disaster, reveals the extent of the devastation. (Donated to the library by Milt Andersen.)

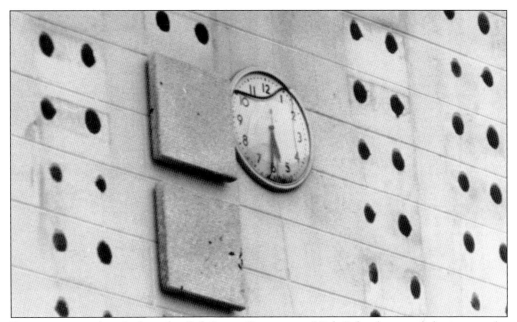

Frozen in time, this clock at the Oak Lawn Community High School stopped the instant the tornado struck. Moving at over 60 miles per hour, the funnel spent just 15 minutes on the ground, but it took only a few seconds to devastate the south end of the high school. (Photograph by Gregory D. Habas; courtesy of the Oak Lawn Public Library.)

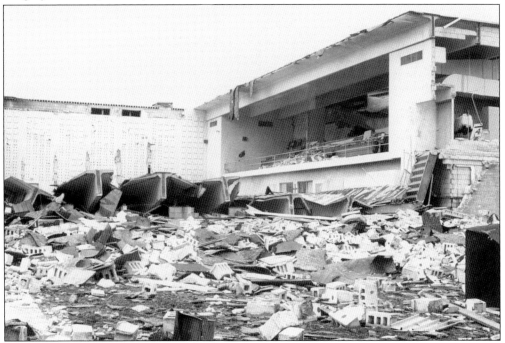

Completed in 1963 at a cost of $1 million, the Oak Lawn Community High School's swimming pool was destroyed when the roof collapsed overhead. Although pieces of stone and steel are scattered everywhere, an untouched rack of clothing is visible on the far right. (Photograph by David A. Johnston; donated to the library by Tom Johnston.)

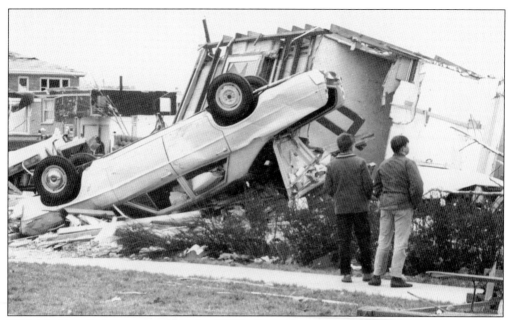

With wind speeds that may have surpassed 200 miles per hour, the tornado overturned automobiles and tore apart homes with relative ease. Observing the damage, two young residents stare in awe at the storm's destructive power. (Photograph by David A. Johnston; donated to the library by Tom Johnston.)

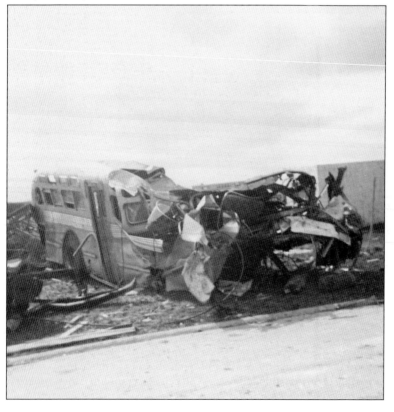

The Suburban Transit Company, located near Ninety-fifth Street and Menard Avenue, saw extensive damage from the tornado. Many of its buses, each weighing around 10 tons, were ripped open by the high winds, while others were thrown hundreds of feet from their original locations. (Photograph by Bob Rolfe; courtesy of the Oak Lawn Public Library.)

In the days following the disaster, a massive cleanup effort was undertaken to remove debris strewn throughout the village. Near the vicinity of Ninety-fourth Street and Massasoit Avenue, rescue workers and volunteers worked around the clock to clear the rubble left by the tornado. (Photograph by Frank Zydek; courtesy of the Oak Lawn Public Library.)

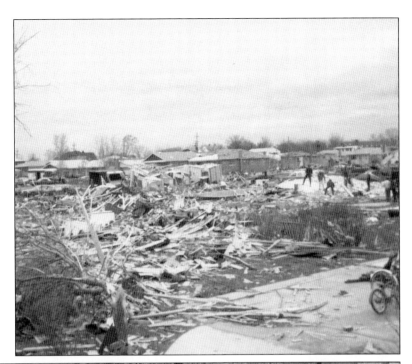

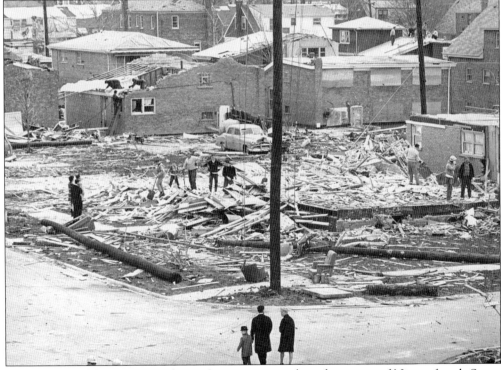

Only a pile of debris remains where a home once stood on the corner of Ninety-fourth Street and Major Avenue. Several of the surrounding buildings also saw significant damage, yet others located just a block away were untouched. (Photograph by Gary Settle; courtesy of the Oak Lawn Public Library.)

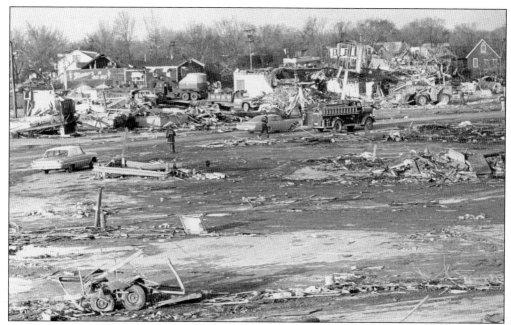

Many of those who witnessed the tornado and its aftermath were veterans of conflicts such as World War II and Korea. When asked to describe the devastation, they commonly compared Oak Lawn to the war-ravaged cities of London, Berlin, and Tokyo. (Courtesy of the Oak Lawn Public Library.)

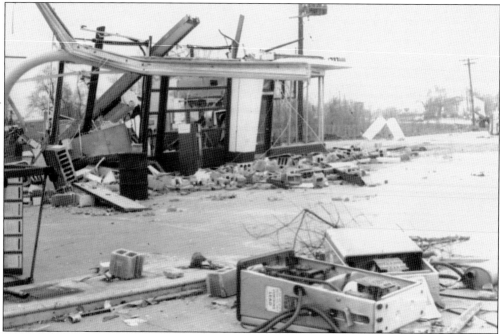

Among the numerous businesses damaged or destroyed in the storm was Basil's Texaco Service Station, located near the intersection of Ninety-fifth Street and Southwest Highway. The tornado's high winds left nothing but an empty shell of broken glass and twisted steel. (Courtesy of the Oak Lawn Public Library.)

Moving northeast, the tornado struck the area surrounding Cicero Avenue and Ninety-first Street. A McDonald's restaurant located near that intersection suffered only minor damage, while other nearby structures, such as the Oak Lawn Roller Rink and Airway Trailer Park, were almost completely destroyed. (Courtesy of the Oak Lawn Public Library.)

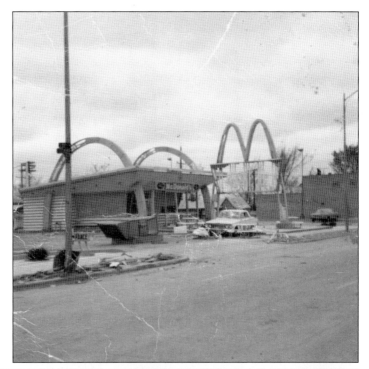

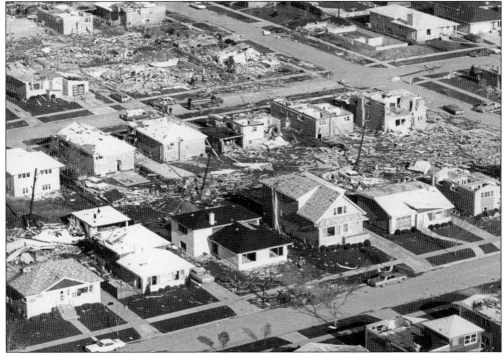

Taken near the intersection of Ninety-fourth Street and Major Avenue, this aerial photograph offers a glimpse of the tornado's enormous scope and fury. Its path of destruction ranged anywhere from 200 feet in width to well over 600 feet, consuming almost everything it touched. (Courtesy of the Oak Lawn Public Library.)

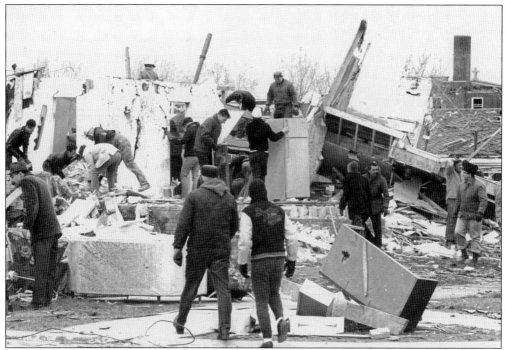

Thousands of volunteers and rescue workers came from all over the Midwest to help clean up the more than 300 homes destroyed by the tornado. Using money borrowed from local banks, Mayor Fred M. Dumke purchased trailers to temporarily house many of the 600 residents left homeless. (Photograph by David A. Johnston; donated to the library by Tom Johnston.)

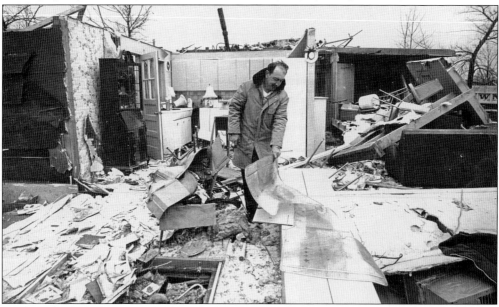

Working slowly, Jack Koven sifts through the remains of his house on Southwest Highway. Koven's wife and two children were at home when the disaster struck and survived by huddling in a tiny hallway as the intense winds ripped apart the walls that surrounded them. (Courtesy of the Oak Lawn Public Library.)

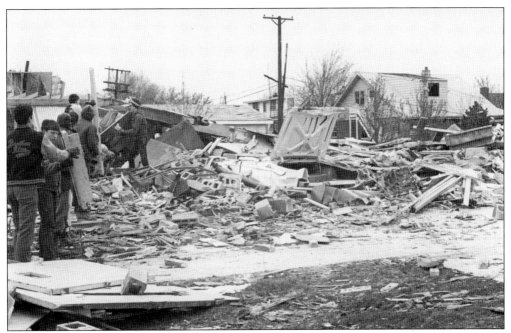

Organized in long chains, workers passed pieces of debris by hand, creating large piles that were later hauled away by the village. In some instances, buildings damaged beyond repair were marked by the fire department and then burned in a controlled blaze. (Photograph by David A. Johnston; donated to the library by Tom Johnston.)

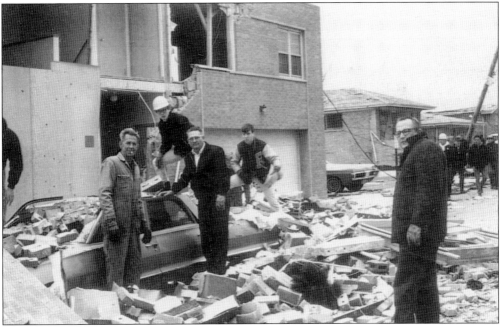

The Jerome Teale home, located at 9416 South Massasoit Avenue, was among the hundreds of buildings damaged or destroyed. The tornado tore open the front of the house and violently threw bricks, stone, and other materials onto a car that was parked outside. (Donated to the library by Mary Teale.)

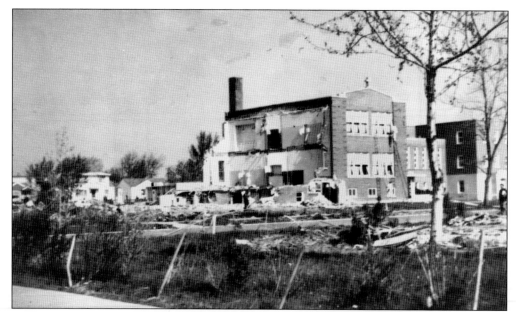

Scheduled to hold Confirmation the night of the tornado, St. Gerald was forced to postpone the service after the school, convent, and rectory were badly damaged. Though no deaths or injuries occurred at the church itself, six parishioners were killed elsewhere in the village, while 100 others lost their homes. (Courtesy of the Oak Lawn Public Library.)

Propelled by high winds with a force that is difficult to comprehend, this wedding album sits deeply embedded in the side of a tree. Many of those who witnessed that day remember the deafening sound of the storm, similar to that of a locomotive, and the unforgettable images created by the tornado's fury. (Photograph by David A. Johnston, donated to the library by Tom Johnston.)

Nine
CELEBRATIONS

Creating bonds and memories that transcend generations, the celebration of holidays, anniversaries, and other events are an important part of Oak Lawn's history. Many of these occasions, such as the end of World War II or the American bicentennial, connect to larger national and world events. Other times, they are of a more local nature and reflect the tastes and attitudes of a particular time. The Oak Lawn Round-Up, which began in 1949, was one of the largest annual events in the village's history, attracting tens of thousands of visitors each year. Featuring a Western theme, the event took influence from well-known television and radio programs, as well as local folklore that told of horse thieves from an era long past. At one point, the Round-Up became so popular that the parade was televised on WGN, with sports commentator Jack Brickhouse as master of ceremonies; however, due to its increasing size, rising costs, and falling revenue, the event ended in 1958. The following year, Oak Lawn celebrated its 50th anniversary, holding a Golden Jubilee that attracted large crowds estimated at 100,000. During the 1960s and beyond, events of this size were rare, although the village continued to commemorate holidays and anniversaries. In addition to larger celebrations, the gathering of families and friends to enjoy recreational time is an important aspect of any community. Located near Ninety-fifth Street and Pulaski Road, Green Oaks Kiddyland was a popular destination for residents. Opened in 1946 with three rides, the amusement park closed in 1971 but remains alive in the memories of those who enjoyed its many attractions. Today, with events like Fall on the Green, the village continues the traditions set forth by earlier residents, further strengthening the fabric of Oak Lawn.

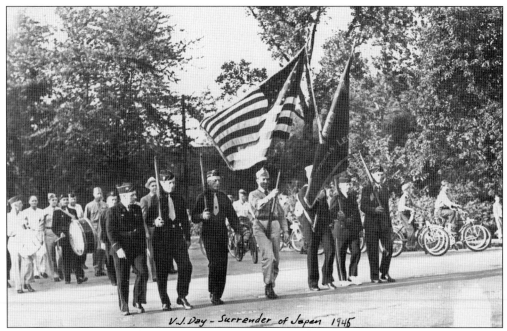

After nearly four years of conflict, the empire of Japan officially surrendered to the United States and its allies in September 1945. Across the country, Americans celebrated the joyous news, and in Oak Lawn residents held a parade to commemorate the sacrifice of its veterans. (Courtesy of the Oak Lawn Public Library.)

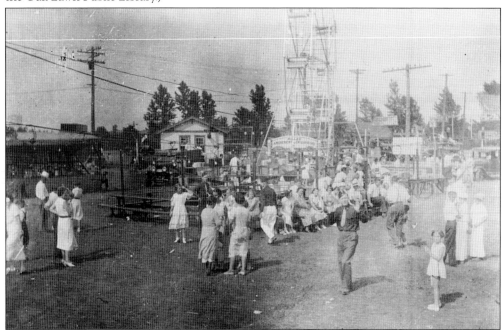

With assistance from the Oak Lawn American Legion and Johnson-Phelps VFW, the 1950 Round-Up featured a Ferris wheel and other carnival rides. In the following years, as attendance grew, more attractions, including a swing carousel and merry-go-round, were added to the festival. (Courtesy of the Oak Lawn Public Library.)

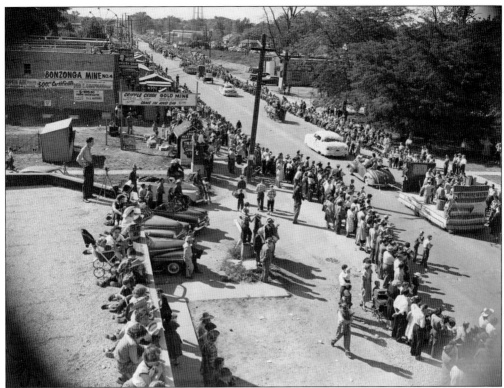

By its fourth year, the Oak Lawn Round-Up had grown far beyond its original scope. Held in September 1952, an estimated 75,000 people from all over Chicagoland attended, which was at that point the largest parade to ever take place in Oak Lawn. (Courtesy of the Oak Lawn Public Library.)

Part of the Round-Up festivities included a mock robbery held at the Oak Lawn Trust & Savings Bank near Ninety-fifth Street and Raymond Avenue. Spectators watched as mounted riders surrounded the Pony Express stagecoach, quickly grabbing bags of loot and making their getaway. (Courtesy of the Oak Lawn Public Library.)

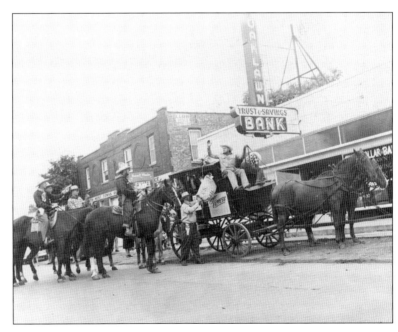

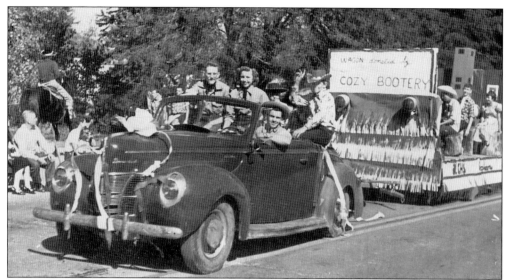

Vehicles and floats of all shapes and sizes were used in the annual Round-Up Parades that ran down Ninety-fifth Street. Although it varied from year to year, some parades featured as many as 100 floats, 400 horses, and a number of other wagons, buggies, and fire engines. (Courtesy of the Oak Lawn Public Library.)

The Round-Up gave thousands of Oak Lawn residents an opportunity to dress in Western-themed clothing and participate in different reenactments. In this staged scene, a local judge, surrounded by a number of armed lawmen, holds a recently captured bandit on trial. (Courtesy of the Oak Lawn Public Library.)

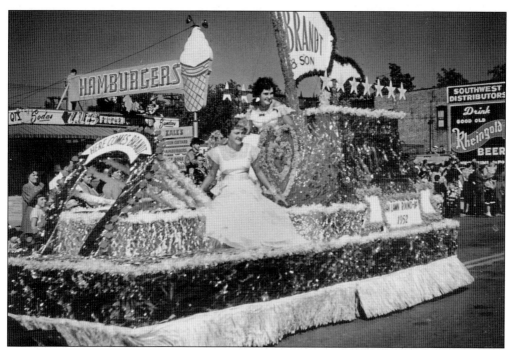

Starting just as Oak Lawn's population began to boom, the Round-Up was used to attract new residents and promote the local economy. With the assistance of the chamber of commerce, many businesses such as William Brandt & Son contributed floats, held sales, and redecorated their buildings in Western themes. (Courtesy of the Oak Lawn Public Library.)

Out of the many traditions that came from the Round-Up, one of the most popular was Mystery Rider. Generally, a well-known resident rode throughout Oak Lawn, handing out coupons and working to keep his or her identity a secret. At the end of the festival, a contest was held to guess the Mystery Rider, with prizes awarded to the most cleverly worded correct answers. (Courtesy of the Oak Lawn Public Library.)

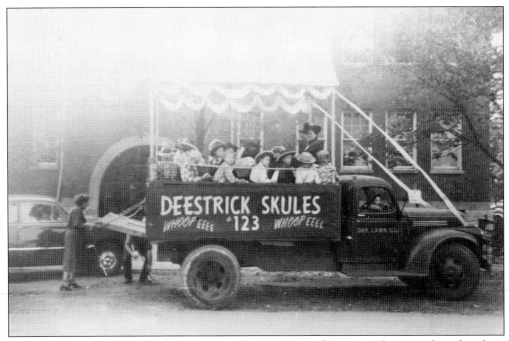

Many Oak Lawn schools played an active role in the Round-Up, providing marching bands to entertain the crowds and building floats for the parade. This photograph, taken in front of Cook School, shows children waiting on the float constructed by School District No. 123. (Courtesy of the Oak Lawn Public Library.)

Dorothy Olsen, secretary of the chamber of commerce, poses on one of the hundreds of horses that were used for the Round-Up. Riding clubs from all over the Chicago area participated in the event, and Western horse shows were a main highlight of the festival. (Donated to the library by the chamber of commerce.)

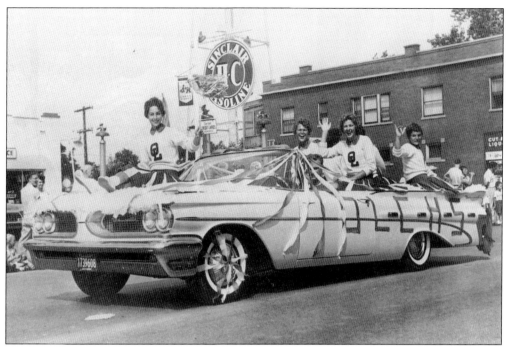

Driving down Ninety-fifth Street near Cook Avenue, cheerleaders from Oak Lawn Community High School wave during the village's 1959 Fourth of July Parade. In the background, businesses such as the Sinclair Service Station (left) and Nick's Tavern (right) are visible. (Courtesy of the Oak Lawn Public Library.)

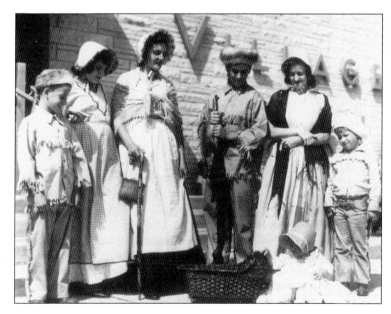

Dressed in full costume, participants of the Golden Jubilee pose in front of the village hall. Held in August 1959, the Jubilee celebrated the 50th anniversary of Oak Lawn's incorporation. From left to right are Ron Meyer, Marianne Meyer, Gene Meyer, Randy Meyer, Kay Tribe, and Tribe's two children. (Donated to the library by Bud Meyer.)

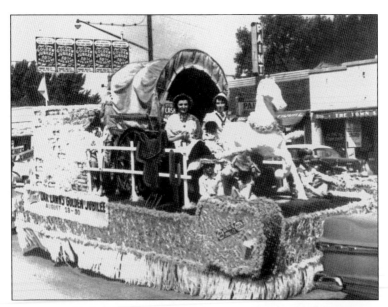

Following in the tradition of the Round-Up, a large parade was held on Ninety-fifth Street during Oak Lawn's Golden Jubilee. As one of the most successful events in the village's history, an estimated 100,000 people attended the weeklong celebration. (Donated to the library by Jack Thompson.)

As part of the Golden Jubilee, the Oak Lawn Post Office created a special cancellation that was stamped onto all outgoing mail. Just one of many organizations to participate in the event, the post office ran this promotion from August 1 to October 31. From left to right are Postmaster Otis Dunn, Margaret Gwynne, and Mayor Harvey Wick. (Courtesy of the Oak Lawn Public Library.)

Sitting behind a mountain of tickets, politician Harry "Bus" Yourell promotes Oak Lawn's Golden Jubilee. Elected as a trustee in 1959, Yourell went on to serve as a state of Illinois representative, Cook County recorder, Worth Township supervisor, and Chicago Water Reclamation District commissioner. (Courtesy of the Oak Lawn Public Library.)

Open from May through October, Green Oaks Kiddyland encompassed 21 acres and was the largest entertainment venue in Oak Lawn. In this 1963 photograph, Steven Vaccaro (left) and his father, Joseph, ride the park's popular roller coaster. (Donated to the library by Joseph Vaccaro.)

By the mid-1960s, Green Oaks Kiddyland contained many attractions, including a Ferris wheel, carousel, Tilt-a-Whirl, handcars, and a small railroad that circled the entire park. Taken in 1964, Bonnie Bila enjoys fresh cotton candy while standing in front of the train. (Donated to the library by Bonnie Price.)

Making their way down Ninety-fifth Street, members of the Oak Lawn Community High School band march in the 1966 Memorial Day Parade. Dating back to its earliest days, Oak Lawn has held public tributes to honor both living veterans and those killed in military service. (Photograph by Don Weinzierl; courtesy of the Oak Lawn Public Library.)

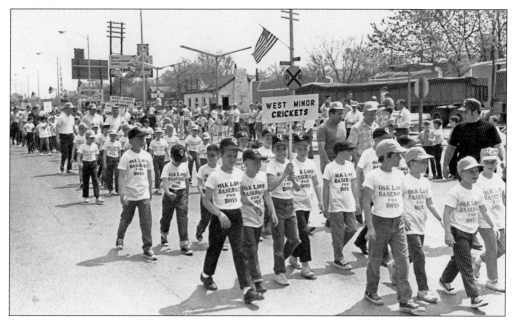

Kicking off their season, members of Oak Lawn Baseball for Boys walk down Ninety-fifth Street near Tulley Avenue in May 1969. In the lead are the players and coaches of the West Minor Crickets, followed by the 1968 champion West Minor Spiders. (Courtesy of the Oak Lawn Public Library.)

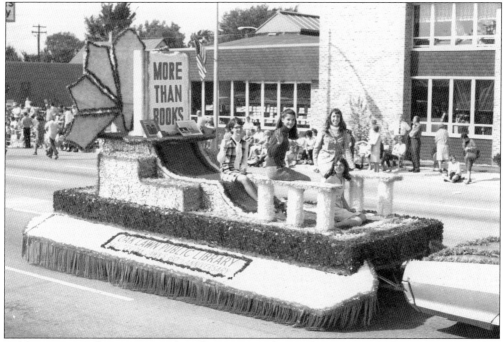

Celebrating its 60th anniversary, the village organized a parade on Ninety-fifth Street in September 1969. The Oak Lawn Public Library participated in the event, constructing an elaborate float that promoted its many services. From left to right are Nancy Haa, Belinda Kleinhenz, Laurel Wolf, and unidentified. (Photograph by Arthur J. Harrison; courtesy of the Oak Lawn Public Library.)

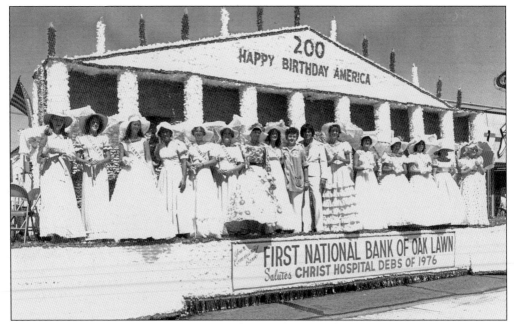

In 1976, the United States honored its 200th anniversary with a nationwide bicentennial. As part of the festivities, the First National Bank of Oak Lawn constructed a float that featured the debutantes of Christ Hospital. (Photograph by Harry K. Thiem; courtesy of the Oak Lawn Public Library.)

In the front passenger seat of the Cadillac, Oak Lawn mayor Fred M. Dumke prepares to join the 1976 Bicentennial Parade on Ninety-fifth Street. Waiting in the back of the car are mayor of Evergreen Park Anthony Vacco (left) and Fred's wife, Martha Dumke. (Donated to the library by Fred M. Dumke.)

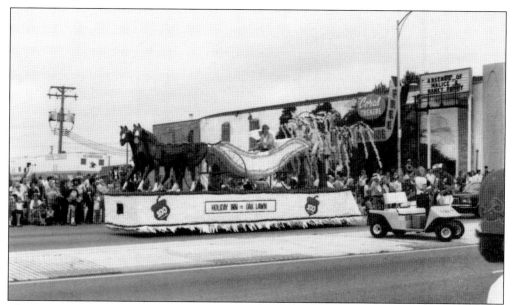

The first of two centennials, an event was held in 1982 to celebrate the 100th anniversaries of the village's first survey and when the name Oak Lawn came into regular use. Featuring two large horses and a buggy, a float provided by the Holiday Inn passes in front of the Coral Theater on Ninety-fifth Street. (Photograph by Howard G. Siebalt; courtesy of the Oak Lawn Public Library.)

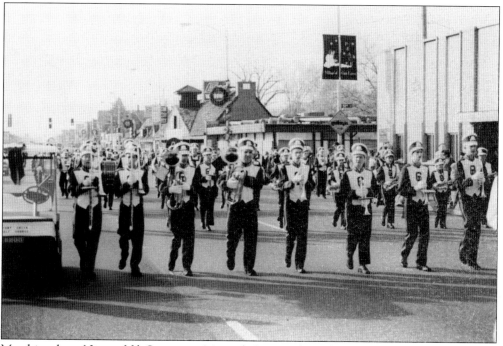

Marching down Ninety-fifth Street near Minnick Avenue, the Oak Lawn Community High School band participates in the 1996 Holiday Parade. Oak Lawn has maintained a strong tradition of public events, creating lasting memories and strengthening ties within the community. (Donated to the library by the Oak Lawn Chamber of Commerce.)

Bibliography

Anderson, Gerald. *Black Oak and After: Law and Order Comes to Oak Lawn*. Oak Lawn, IL: Oak Lawn Public Library, 1982.
Biere, Verlyn, and Grant Suhs. *Black Oak and After: The Oak Lawn Public Library*. Oak Lawn, IL: Oak Lawn Public Library, 2009.
Gavin, Tom, Judy Grant, Bill Sullivan, Peggy Nevins, Sandy Rehnquist, and Agnes Donlon. *Oak Lawn: A Century of Growth*. Oak Lawn, IL: Oak Lawn Chamber of Commerce, 1982.
Jacobsen, Ray. *Black Oak and After: The First Churches of Oak Lawn*. Oak Lawn, IL: Oak Lawn Public Library, 1979.
Nevins, Peggy. *Black Oak and After: Voices of the Past*. Oak Lawn, IL: Oak Lawn Public Library, 1983.
———. *Black Oak and After: History of the Oak Lawn Fire Department*. Oak Lawn, IL: Oak Lawn Public Library, 1984.
Rodie, James Jr., Herbert Hopkins, Walter Rodie, and Walter Hopkins. *Oak Lawn Year Book*. Chicago: Wm. L. Erickson & Co., 1912.
Southwest Suburbanite, "Oak Lawn Golden Jubilee Edition." August 1959.
Welles, Gordon. *Black Oak and After: Schools in Oak Lawn 1*. Oak Lawn, IL: Oak Lawn Public Library, 1979.
———. *Black Oak and After: Schools in Oak Lawn 2*. Oak Lawn, IL: Oak Lawn Public Library, 1979.
———. *Black Oak and After: Oak Lawn Round-Up, 1949–1958*. Oak Lawn, IL: Oak Lawn Public Library, 1980.
Welles, Gordon, and Gerald Anderson. *Black Oak and After: Village Adopts New Name, Government*. Oak Lawn, IL: Oak Lawn Public Library, 1981.
Wolfe, Barbara, Mary Neslon, Rose Franceschini, and Peggy Nevins. *Black Oak and After: The 1967 Oak Lawn Tornado*. Oak Lawn, IL: Oak Lawn Public Library, 1991.

Numerous other resources, which do not appear in the bibliography, were utilized while researching this book. If you are interested, please contact the Local History Unit for further details.

Index

Banana's Steak House, 74
Behrend's Hardware, 2, 10, 12, 66, 67
Brandt, Albert, 80, 82, 91
Brandt, Mary, 82, 84
Brandt, Otto, 21, 22, 80
Brant Building, 12, 13, 72
Center of Public Safety, 96–98
Christ Community Hospital, 54, 62
Columbus Manor Fire Department, 92
Cook School, 14, 36, 37, 51, 118
Coral Theater, 69, 125
Covington School, 30, 39, 40
Dearborn Heights School, 43
Dumke, Fred M., 50, 53, 56, 71, 75, 82, 85, 96, 110, 124
Elim Evangelical Free Church, 31, 32
Fairway Foods, 75, 103
First Congregational Church, 25–27, 34
Gaddis, William B., 79
Garden Methodist Church, 32
Gasteyer School, 42
Golden Jubilee, 119–121
Grandview Park Fire Department, 94, 95
Green Oak American Legion, 51, 52
Green Oaks Kiddyland, 121, 122
Harker, Elmore Sr., 91, 93
Harnew School, 33, 41
Holiday Inn, 71, 125
Jack Kilty's Restaurant, 53, 74, 84
Jack Thompson Oldsmobile, 71
Johnson-Phelps VFW, 50, 51, 114
Kolb, Ernie, 29, 54, 83, 85–88

Larsen's Hall, 2, 12, 78
Montgomery, James, 15, 78
Oak Lawn Baseball for Boys, 56, 57, 123
Oak Lawn Chamber of Commerce, 53, 117, 118
Oak Lawn Community High School, 45–47, 86, 103, 105, 119, 122, 125
Oak Lawn Park District, 57–59
Oak Lawn Public Library, 59–62, 123
Oak Lawn Lake, 17, 58
Oak Lawn Methodist Episcopal Church, 27
Oak Lawn Train Depot, 14, 21, 85
Oak Lawn Trust & Savings Bank, 2, 10, 67, 115
Pilgrim Faith United Church of Christ, 34
Powell, Dr. Thomas, 85
Powers, Jayne, 86, 87
Richards High School, 47, 48
Round-Up, 2, 114–118, 120
Schultz's Store, 12, 73
Simmons School, 37, 38
Spitzer's Service Station, 64, 65
St. Gerald, 2, 28, 29, 43, 44, 112
St. Linus, 44
St. Louis de Montfort, 33, 45
St. Paul Lutheran, 30, 31
St. Raphael the Archangel, 33, 34
Sullivan, Skip, 46
Sward School, 40
Trinity Evangelical Lutheran Church, 12, 19, 24, 25
Wick, Harvey, 61, 80, 81, 120
Yourell, Harry "Bus," 84, 121

Discover Thousands of Local History Books
Featuring Millions of Vintage Images

Arcadia Publishing, the leading local history publisher in the United States, is committed to making history accessible and meaningful through publishing books that celebrate and preserve the heritage of America's people and places.

Find more books like this at
www.arcadiapublishing.com

Search for your hometown history, your old stomping grounds, and even your favorite sports team.

Consistent with our mission to preserve history on a local level, this book was printed in South Carolina on American-made paper and manufactured entirely in the United States. Products carrying the accredited Forest Stewardship Council (FSC) label are printed on 100 percent FSC-certified paper.